TALES

of

TENNESSEE

forgotten TALES of TENNESSEE

Kelly Kazek

illustrations by
Kyle McQueen

THE
History
PRESS

Published by The History Press
Charleston, SC 29403
www.historypress.net

First published 2011
Manufactured in the United States

ISBN 978.1.60949.156.7

Library of Congress Cataloging-in-Publication Data

Kazek, Kelly.
Forgotten tales of Tennessee / Kelly Kazek.
p. cm.
ISBN 978-1-60949-156-7
1. Tennessee--History--Anecdotes. 2. Tennessee--Social life and
customs--Anecdotes. 3. Tennessee--Biography--Anecdotes. 4.
Curiosities and wonders--Tennessee--Anecdotes. I. Title.
F436.6.K39 2011
976.8--dc22
2010052600

For my Tennessee family, filled with storytellers and lovers of these beautiful hills. I love you all.

ACKNOWLEDGEMENTS

While I received much assistance in researching *Forgotten Tales of Tennessee*, readers won't find a bibliography or source page in the back of this book. As a journalist for more than two decades, I am accustomed to sourcing my material within the stories, which is what I have done in here. In cases where information is not attributed, it was considered as accepted fact by three or more official sources.

There are, however, others I need to acknowledge for their help, including some of my Tennessee relatives who are storytellers themselves: Baxter "Uncle Bob" Blackburn and Jewell Shouse, thanks for sharing your stories. Thanks, too, to Aunt Dot and Uncle George Horne.

I also received invaluable assistance from Brennan LeQuire at the Blount County Library in Maryville; Mancil Johnson, archivist with Tennessee Tech University; Joe

ACKNOWLEDGEMENTS

Schibig, grandson of E.T. Wickham; the staff of Morrell Music; historians at Embury Cemetery; and the City of Powell. The writings of the late Jill K. Garrett of Columbia in the book *Hither and Yon* and Scotty Moore's recollections of Elvis on his website were very helpful.

Websites that provided information for some stories on these pages include the Tennessee Encyclopedia of History and Culture, Tennessee State Library and Archives, the Orpheum Theater, Oliver Springs Historical Society, clanbreazeale.com, Find A Grave, the Elephant Sanctuary at Hohenwald, Patrick Sullivan's, 127sale.com, Chattanooga Bakery, the Peabody Hotel and Pal's Sudden Service.

Thanks to Jean Cole for reading the manuscript.

And, as always, thanks to my beautiful daughter, Shannon, for her patience and to my Alabama family and friends for supporting me throughout this process.

Introduction

Since I was very young, I have been visiting the beautiful, rolling hills of Tennessee. Whether my family was joining relatives for a "dinner on the ground" at the tiny church where my grandmother once sang or going to take a last look at my great-grandparents' old homestead before it was demolished, we always held our middle Tennessee folks and the land they helped settle close to our hearts.

My grandmother, Shannon Blackburn Gray, and two of her siblings, Baxter Blackburn and the late Ruth Vaughan, have written many accounts of our family's past and painted a detailed picture of their lives, growing up on a farm near Columbia, Tennessee. My mother, Gayle Gray Caldwell, was born in Columbia, and now she is buried

there, alongside my father in the graveyard next to the little white Goshen United Methodist Church.

That church is mentioned in the following pages, as is another family legend: Aunt Betsy Trantham, who is alleged to have lived to be 154 years old, is reportedly related to the Blackburns.

Tennessee is one of those states particularly rich in lore and in storytellers, like those in my own family. In researching this book, I was surprised and excited to find how much of the state's history has been preserved.

I tried to focus *Forgotten Tales of Tennessee* on stories that you may not have heard elsewhere. Or, if a story is commonly known, I tried to find its unusual "back story."

Elvis and country music stars weren't tops on my list, although I did manage to slip in one mention of Elvis's pelvis and a few mentions of unusual incidences in country music.

Tennessee is also unusual in its shape: its regions are identified as west, middle and east. There is no north or south. In each of these regions is a booming city—Memphis in the west, Nashville in the center and Knoxville to the east—teeming with history. All are represented here.

Inside, you will find many Colorful Characters, such as the real "boy named Sue"; Strange Sites, such as the Spaceship House; Intriguing Incidents, like the Mysterious Murder of the Spinster Sisters; Tombstone Tales, which includes a section on laugh-out-loud epitaphs; Odd

Occurrences, such as the Legend of Booger Swamp; and Curious Creatures, like Dammit the Dog.

I hope you enjoy reading about Tennessee's quirky stories as much as I enjoyed researching them.

Chapter 1

COLORFUL CHARACTERS

RICKEY DAN OR CRAZY JACK: STRANGE CASE OF UNKNOWN IDENTITY

One of the strangest cases of unknown identity begins like this: "About the year 1825 there was born of humble parentage, on the banks of the Cumberland river, in Smith County, Tennessee, a child named William Newby," according to an 1893 story in the *Otago Daily Times* in New Zealand.

The story of William Newby, alias "Crazy Jack"—who was possibly Daniel Benton, alias "Rickety Dan"—was featured in newspapers across the world.

Newby's family moved to Illinois when he was a child, and he would eventually marry, have children and, in 1861, enlist in the Union army.

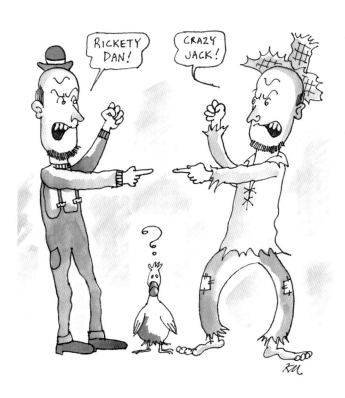

According to the New Zealand article, Daniel Benton was born in 1845 in Illinois and moved as a child to Nashville, Tennessee. As a child, he frequently suffered from rickets, which affected his limbs and made him walk in a wobbly fashion. He soon became known as Rickety Dan.

A wanderer, Rickety Dan went from poorhouse to poorhouse, and he was eventually sentenced to a Nashville prison for stealing horses. In the meantime, William Newby was reported killed at the 1862 Battle of Shiloh in Tennessee.

However, a man who showed up in Illinois thirty years later, claiming to be William Newby, said he had suffered a head wound at Shiloh, was taken prisoner and sent to Andersonville. There, he could not remember his identity, so his fellow prisoners called him Crazy Jack.

After his release at the end of the war, Newby roamed through Georgia, Alabama and Tennessee before he eventually made his way back to Illinois, where he was spotted by a relative. When he was presented to his family as William Newby, family members said they recognized him. But Newby ran into a glitch when he tried to get back pay from a Civil War pension. The government claimed he was Daniel Benton, and he was fraudulently trying to get the pension funds, which would have totaled about $20,000. He was jailed and indicted.

During a trial, two men on the burial detail following the Battle of Shiloh swore on the stand that they buried Newby's body. However, several Union veterans said they recognized Newby as Crazy Jack from Andersonville

prison camp. Additional witnesses said that while roaming Tennessee, Newby/Crazy Jack was mistaken for Daniel Benton/Rickety Dan, and he was arrested and taken to the same prison from which Benton had previously escaped.

Newby was released from prison as Rickety Dan in 1889, where he wandered to a poorhouse in Mount Vernon, Illinois, where the brother of William Newby also resided. The brother recognized Newby, and the two reminisced as Newby began regaining memories.

After leaving the poorhouse, Newby went eighteen miles to McLeansboro, near the town where he once lived, and ran into his son, according to newspaper accounts of testimony.

Newby himself said in his deposition:

> *My head was treated but I don't remember what was done. A "piece" was put in my head while I was in the hospital in this penitentiary prison of war…I did not know anybody at Andersonville. I was known by the name of Crazy Jack, and I laid in the filth and ditches. I went naked with an old yarn gray shirt tied around my waist. I was not myself there. I was as crazy as a bed bug, and had no sense at all.*

Seventy witnesses said the man on trial was Rickety Dan; more than twice that number swore he was William Newby. Physicians even testified the man on trial had never had rickets.

However, a jury took twenty minutes to find Newby guilty.

Weeks later, on August 29, 1893, the *Chicago Daily Tribune* reported: "The efforts made to secure a new trial in the case of the individual variously known as William Newby and Daniel Benton have been unsuccessful, and he was today sentenced to serve two years in the Chester Penitentiary, where he will probably be taken tomorrow."

The reporter for the *Otago Daily Times* editorialized:

> *There is a strong possibility that he is Daniel Benton; there is a possibility equally as strong that he is William Newby. If he is Benton then the Government would have lost 20,000 dollars through fraud; if Newby, what a golden opportunity to reimburse this nineteenth-century martyr for his wasted life and the injuries received while in the service of his country!*

According to the 1963 book *Legends and Lore of Southern Illinois* by John W. Allen, after Newby was denied a new trial, he served his time, was released and wandered back to Georgia in the vicinity of Andersonville. He died while there and was buried in a potter's field, according to Allen.

This strange tale was the subject of the 1893 book by Gilbert Jaspere George called *William Newby or the Soldier's Return*, which was republished in 1993 as *William Newby or the Civil War Soldier's Return*.

SUE, HOW DO YOU DO?

Tennessee drew much attention from the famous Scopes Monkey Trial held in the town of Dayton in 1925. The trial was instigated by a group of men, including an attorney named Hicks, to test a law prohibiting teaching evolution in schools and to bring attention to Dayton. A member of the group that devised the plan for the trial was Sue Kerr Hicks, an attorney born in Madisonville on December 12, 1895. As you might assume, there were few female attorneys in the south in 1925. Hicks was, in fact, a boy named Sue.

And this is how another legend arose from the famous trial, although one known to fewer people.

Hicks, who would later serve as a circuit court judge, was one of the "drugstore conspirators" who were meeting at F.E. Robinson Drugstore in Rhea County when they saw an ad seeking challengers to the law against teaching the theory of evolution. They devised the plan to have local teacher and Hicks's friend, John Scopes, admit to teaching evolution and have him arrested. The case would then go to court and draw the publicity needed, they hoped, to have the antievolution Butler Act overturned. The men wanted Scopes to be convicted and the case to eventually be heard before the U.S. Supreme Court.

The case went as planned—to a point. Scopes was convicted, but the Tennessee Supreme Court upheld the Butler Act in 1927, effectively putting an end to the Scopes case. Also, while the trial did bring attention to

Dayton, much of it was negative and the residents were labeled as "backward."

The Butler Act would eventually be repealed in 1967.

But Hicks's legacy lives on in song. It is believed that Hicks was the inspiration for the song "A Boy Named Sue," written by author Shel Silverstein and famously recorded by Johnny Cash. Silverstein, who paradoxically drew cartoons for *Playboy* magazine and wrote best-selling poems for children, was known for writing novelty songs, including "The Cover of the Rolling Stone" and "Boa Constrictor," a children's poem set to music and recorded by Cash.

According to lore, Silverstein attended a judicial conference in Gatlinburg at which Hicks was a speaker, and, upon hearing Hicks's name announced, he got the idea for the song title. This story has credibility because, after all, how many men named Sue would Silverstein have met in his life? Other than the title, however, the song has little to do with Hicks's life.

The song refers to a young boy who is taunted because of the name and subsequently becomes a fighter. He spends years searching for the absentee father who named him, and upon finding him, he learns that his father named him Sue so he would become tough enough to handle life's challenges.

It is true that Hicks's name was bestowed upon him by his father, Charles Wesley Hicks. But Hicks, born into a family of attorneys, was a bookish-looking man who was

named for his mother, Susanna Coltharp Hicks, following her death within days of giving birth to her son.

He would also claim that the name did not lead to problems in his life. In 1970, Hicks was quoted in the *New York Times*: "It is an irony of fate that I have tried over 800 murder cases and thousands of others, but the most publicity has been from the name 'Sue' and from the evolution trial."

Hicks was buried in Haven Memorial Gardens in Madisonville beneath a small marker with his name and that of his wife. It reads: Sue K. and Reba B. Hicks. He died in 1980.

AMERICA'S FIRST SERIAL KILLERS ROAMED TENNESSEE

Surely the kindly man who offered aid to a traveling family had nothing to fear from the two men and three pregnant women. Did he?

Had he known the men were the notorious Harpe brothers, who had just passed through Tennessee's Cumberland Gap into Kentucky, he might have hesitated to pay for the group's breakfasts and ask them to accompany him along the Wilderness Trail.

His trust would be his downfall. The brothers would soon make the well-intentioned man the latest victim on their own trail, the Trail of Carnage.

Those who follow true-crime stories often read that a man named Dr. Henry Howard Holmes was America's first serial killer.

Many of Holmes's grisly crimes were committed in a hotel he opened in Chicago to lure travelers to the 1893 World's Fair. He was finally captured and confessed to twenty-seven murders—he is thought to have committed as many as one hundred—and was executed in 1896. But a century before Holmes's capture—just as America was being founded—two brothers were committing horrific murders across Tennessee and Kentucky.

Tennessee historians have dubbed Micajah and Wiley Harpe as the nation's true first serial killers.

Micajah, called "Big Harpe," and Wiley, called "Little Harpe," were born in North Carolina—Micajah in 1768 and Wiley in 1770. When the boys were children, their family was persecuted because their father fought with the British during the American Revolution. Some say their bitterness drove them to lives of crime.

The Harpe brothers' reign of terror took place mostly in the 1790s. Accounts of their exploits vary widely, but they are credited with the murders of thirty-five to forty people. These accounts fit with the modern definition of serial killer, a person who commits multiple murders over a period of time.

One of the oft-repeated tales about the brothers is that the men traveled with three women: each brother had a wife, plus there was one "auxiliary wife." Micajah was

married to Susan Roberts, while his brother married Sally Rice, a minister's daughter from Tennessee. A woman who went by the name Betsey Roberts, and said she was Susan's sister—but who is thought to have been Maria Davidson—was the "extra" wife.

The women accompanied the men on a crime spree that began in Knoxville, then the capital of Tennessee, arriving between 1795 and 1797.

The group was living on a farm near Beaver Creek when they hurriedly left in 1798 after being accused of stealing a neighbor's horses.

At a tavern outside Knoxville, the brothers murdered a man named Johnson, who may have been the one to tell the neighbor about the horse thefts. The man's body was later found floating in the Holstein River. The body was eviscerated, and the cavity filled with stones, which would become known as a Harpe trademark.

The women accompanied the brothers on a rampage through Tennessee, killing and thieving, until the Cumberland Gap was discovered and pioneers began to enter Kentucky.

According to several written accounts from the 1800s, it was in December 1798 that the brothers entered the Gap, heading for Crab Orchard, a point where roads diverged to Louisville and Cincinnati. By this time, all three women were pregnant. The group entered John Farris's tavern, looking for food, but they were turned away because they had no money. Stephen Langford

from Virginia took pity on the miserable-looking troupe and bought them breakfast.

He then asked if the party wanted to join him along the Wilderness Trail. Historians report that Langford's remains, mutilated almost beyond recognition, soon were found along the trail.

Eventually, the Harpes and the women were captured and taken to jail in Danville, Kentucky. The jail had to be reinforced, as the men had a reputation for escaping. Also, the jailers had to hire midwives for the three pregnant women and house them through a long, bitterly cold winter.

True to their reputations, the brothers did escape, leaving behind the mothers of their children. Before the women came to trial, they gave birth: Betsey in February, Susan in March and Sally in April. At their murder trials, motherhood earned them sympathy. Sally was acquitted, Betsey was found not guilty, while Susan was convicted. However, Susan's conviction was later overturned.

The three murder suspects, now free, were given clothes, money and a horse donated by townspeople so they could return to Tennessee.

Instead, they rejoined their men, but their long, grisly crime spree soon would come to an end. Details vary on how the brothers met their ends, although most agree that Micajah was shot and beheaded in 1799. He was thirty-one.

The brothers were being trailed by a posse that included Moses Stegall, whose wife and child had been

killed by the Harpes. A member of the posse, John Leiper, is said to have shot Micajah in the back, paralyzing him. While Wiley escaped onto the Natchez Trace, Stegall reportedly used Micajah Harpe's own knife to cut off the outlaw's head.

According to legend, Micajah's head was nailed into the forks of a tree near what is now Dixon, Kentucky, leading the community to be called Harpe's Head for many years. Wiley was captured in 1803 and hanged a year later when he was thirty-four. Some historians claim Wiley also was beheaded after the hanging.

Sally Rice returned to Tennessee and the home of her preacher father. She would later remarry. Betsey moved to Illinois, where the group had once gone on a short murderous spree, and remarried and raised a family. She is believed to have died in the 1860s.

It is unknown if Susan remarried, but she is said to be buried in Tennessee. She, too, likely died in the 1860s.

THE MADAM WHO HELPED SAVE MEMPHIS

It was a terrible time in Memphis.

While the people of the city had experienced the tragedy of yellow fever before—in 1828, 1855 and 1867—what would come in the 1870s would be catastrophic. In 1873, the fever struck Memphis with a

vengeance. One of the people trying to stem the deaths was Annie Cook, a well-known Memphis madam, who had previously been a nurse.

Cook came to Memphis from Ohio, and her date of birth is uncertain, although historians guess it was around 1840. Records show Cook stopped to work for a family in Kentucky on her travels from Ohio. There, she is remembered for caring for poor smallpox victims. She moved to Memphis to establish the upscale brothel known as Mansion House on Gayoso Street, sometime after the Civil War.

When the 1873 epidemic hit, Cook sent her "girls" away from the house and opened it as a hospital to care for the fever stricken. Before it was over, two thousand residents would die, but who knows what the toll may have been without the aid of Cook, who exposed herself to the deadly fever to save others.

Memphians were relieved when the epidemic ended. But only five years later, a more devastating one would ravage the city. The year 1878 began with a mild winter. A lengthy stretch of spring weather and an unusually hot summer created the perfect breeding ground for mosquitoes that carried the disease. Memphis leaders heard an epidemic had struck New Orleans and formed a blockade to monitor who entered the city.

It was too late.

On August 13, the first death of the epidemic was reported in Memphis. Recalling the horrific deaths a few

years earlier, residents fled the city in droves, with nearly twenty-five thousand leaving in the first two weeks.

Once again, Cook opened her mansion and cared for the sick.

Before the epidemic ended, more than seventeen thousand people would contract the disease, and more than five thousand would die. Cook's efforts did not go unnoticed. Two of the prostitutes from her brothel decided to stay and work as nurses. The epidemic would come to an end in October, but it was too late for Annie Cook. She died September 11, 1878, of yellow fever.

A benevolent society called the Howard Association, which was formed in several southern cities to minister to those afflicted with yellow fever, showed its respect for Cook by moving her grave to the organization's plot in Elmwood Cemetery.

In the book *A History of Yellow Fever: The Yellow Fever Epidemic of 1878, in Memphis, Tennessee*, the author, J.M. Keating, wrote that Cook's grave

> *strewn with flowers, is among the prominent features of the Howard's lot in Elmwood. She did the best she could, and, after a troubled life, the prayers throughout this broad land go up this bright morning to the Throne, that she sleeps in peace: "Let sweet-voiced Mercy plead for her, who silent lies beneath the sod, nor let proud, erring man assume, the province of her Judge, her God."*

The book, which was published by the Howard Association in 1879, quotes the September 12 edition of the *Memphis Appeal*:

> *Annie Cook, the woman who, after a long life of shame, ventured all she had of life and property for the sick, died September 11 of yellow fever, which she contracted while nursing her patients. If there was virtue in the faith of the woman who but touched the hem of the garment of the Divine Redeemer, surely the sins of this woman must have been forgiven her. Her faith hath made her whole—made her one with the loving Christ, whose example she followed in giving her life that others might live. Amid so much that was sorrowful to an agonizing degree, so much that illumined the grace of a common humanity, and so much that disgraced that humanity, the example of that brave woman stands by itself, singular but beautiful, sad but touching. The very expression of that hope the realization of which we have in the words, "Inasmuch as ye have done it unto the leader of these my brethren, ye have done it unto me." Out of sin, the woman, in all the tenderness and true fullness of her womanhood, merged, transfigured and purified, to become the healer and at last to come to the Healer of souls, with Him to rest forever. She is at peace.*

What became of Cook's original headstone is unknown, but in 1979, she received a new one, erected by Mr. and Mrs. J.D. Taylor and the Catholic organization Brothers of the Sacred Heart, South Carolina. It is inscribed:

> *Annie Cook*
> *Born 1840*
> *Died of yellow fever 1878*
> *A nineteenth century Mary Magdalene*
> *who gave her life while trying to*
> *save the lives of others*

Another big-hearted prostitute mentioned in *A History of Yellow Fever* was Lorena Mead. Mead, a young woman from Louisiana, also cared for the sick and helped dress victims for burial during the 1878 Memphis epidemic. Her occupation was listed in the 1870 census as "bawd." She was twenty-six years old at the time.

According to the book, she turned to prostitution when she was left alone and destitute following the Civil War. But her legacy would be that of a "veritable ministering angel," Keating writes.

"There are bodies rotting in the potter's field she dressed for their narrow home and there are convalescents walking in the streets today who speak her name with gratitude and veneration." Mead apparently survived the epidemic, but how long she lived and her burial site are unknown.

AUNT BETSY LIVED FIFTEEN DECADES, GIVE OR TAKE

Elizabeth Eppinger Trantham lived a full life that ended in the 1800s in Maury County, Tennessee.

Some would say it was more than full, considering she lived to be 154 years old, give or take a decade. Aunt Betsy, as she was known to many, is listed in *Drake's Dictionary of American Biography* as the one of the world's oldest surviving humans.

Some family members, including her great-grandson, claimed Aunt Betsy was a mere 149 at her death.

Records show that she gave birth to her twelfth and last child at age sixty-five.

Elizabeth Trantham died on January 10, 1834, in Maury County.

The date of her birth is estimated to be in the late 1600s, but the exact date is the subject of historical argument. Jill K. Garrett, a writer of historical columns for the *Columbia Herald* newspaper, gives newspaper articles, census records, letters, county court records and *Drake's Dictionary* as sources to verify Aunt Betsy's longevity.

Articles about Betsy include one in the *National Gazette* from Washington, D.C., in 1834 and the *Fayetteville Observer* in 1871.

In 1820, a census worker recorded her age as 126. Using this record, Aunt Betsy would have been 140 at her death.

The first-known record of Betsy's life, according to Garrett, describes a 1702 trip to the British colonies. When her ship docked in Southampton, England, to take on more passengers, a then sixteen-year-old Betsy is said to have witnessed the coronation of Queen Anne.

When she arrived in the colonies that would become America, Betsy settled in Virginia and married an Eppinger. She had eight children before his death.

She then moved to South Carolina and married Martin Trantham, with whom she had four children. She made medical history when Martin Jr. was born when she was sixty-five. Betsy moved to Maury County when she was about 122 years old.

Her family reported that she became nearly blind at about 120 years of age, had poor eyesight for about fourteen years and then regained near-perfect vision until her death.

She was unable to walk during her last few years of life, and caregivers used the old-fashioned method of sandwiching her between two mattresses to keep her warm. Legend says that, for the last twenty years of her life, she could not distinguish between vinegar and sugar.

Garrett said Betsy's great-grandson described her as a "tall and thin with prominent, rather masculine, features and deep-set eyes which always had a merry twinkle."

Aunt Betsy is no longer listed in records as the oldest-living human, having long since been out-distanced by others, such as Shirail Muslimov of the Soviet Union, who claimed to be 161 in 1967.

A few of Betsy's descendants are buried in the cemetery at Goshen United Methodist Church in Maury County. It is believed Betsy was laid to rest there, too. But just as the story of her life raises many questions, so does Betsy's final resting place: If she is buried at Goshen, the grave was either unmarked or the marker destroyed.

Historians likely will never know just how old Maury's oldest citizen was.

The Man Who Attended His Own Funeral

On Friday, June 24, 1938, five carloads of tourists arrived in Roane County, Tennessee. They would be the first of many. They had driven to Cave Creek Baptist Church near Kingston to be sure to get a good spot for a huge upcoming event. It wasn't a concert or play people had come to see—it was a funeral. The rites, however, were not for a celebrity. This funeral was for a farmer, one of Roane County's most ordinary citizens.

Why would his funeral draw a crowd of people who didn't know him? Mainly because the person for whom the funeral was to be held wasn't dead yet.

The funeral for Felix Bushaloo Breazeale, seventy-three, known as "Uncle Felix" or "Uncle Bush," was held Sunday, June 26, 1938. Uncle Bush was the guest of honor at his own funeral. The carloads of tourists had

read about the strange event in numerous newspaper accounts across the country, beginning with the *Roane Banner*, which was owned at the time by a friend of Felix's. The story soon was spread through the Associated Press and United Press International.

Felix was born June 29, 1864, in Roane County to Drury Wood Breazeale and Sarah Littleton Breazeale. He was one of eight children and spent his life farming. According to family history at clanbreazeale.com, Felix's strange odyssey began in 1937, when the ever-practical farmer cut down a black walnut tree from which to build his own coffin. An onlooker asked what he was doing. A discussion about funerals followed, and Felix said it was a shame people could not attend their funerals, so they could hear what is said about them. The plan was hatched. As soon as the coffin was completed, the scruffy, bearded Felix Breazeale would throw his own funeral and invite the entire town.

When the big day rolled around the next year, as many as eight thousand people had gathered at Cave Creek Baptist Church. According to the article published June 30 in the weekly edition of the *Roane Banner*, traffic caused the funeral procession to be about forty minutes late. Felix rode in the top seat of the hearse in which his empty coffin was transported.

Before the sermon began, Felix welcomed guests while sitting in front of his hand-hewn coffin and waving a cardboard "funeral home" fan. He "signed" programs with an "X." The Friendly Eight Octette of Chattanooga sang

"Where We'll Never Grow Old" and "On Jordan's Stormy Banks I Stand."

In his sermon, the Reverend Charles E. Jackson of First Christian Church of Paris, Illinois, talked about Felix's life. He began with the words:

> *It is a very extraordinary occurrence when a man shapes his coffin with his own hands, a minister travels five hundred miles to be present and ten thousand interested people assemble for a funeral service while the individual is yet alive. Much good may and should come from such a service. It is a funeral service divested of the usual tears and heartaches and heart breaks in which we may place the stern realities of life.*

One event from Felix's past was not mentioned by Reverend Jackson. Felix once was charged with murder. In 1891, Felix was jailed, charged with killing James C. Breckinridge Smith, thirty-five, known as "Brack," a deputy in Roane County.

Smith was a well-respected lawman who left behind a wife and six children. His obituary in the *Knoxville Daily Journal* on August 8, 1891, stated:

> *He had returned home from a trip to Kingston, and while they were in the stable yard unhitching a horse from a wagon some unknown party from ambush fired a charge of buckshot into his body from behind. The*

party was concealed in a cornfield near the barn. He fell forward and the only words he said were, 'I'm killed' and expired immediately.

Felix spent much of the next year in jail but was eventually tried and acquitted. In 2010, a film called *Get Low*, partly based on the Felix Breazeale story, was released. In the movie, Robert Duvall portrays a character called "Felix Bush," who is a hermit in a small town who gives his own funeral. The townspeople have long speculated on Felix's past, with some saying he had killed in cold blood. The film also starred Bill Murray, Sissy Spacek, Gerald McRaney and Lucas Black.

Felix died five years after his first funeral. He was buried in Cave Creek Cemetery, adjoining his church.

THE BLIND KNIGHT

Francis Joseph Campbell was four years old when, according to lore, he was blinded by a locust branch near his home in Liberty, Tennessee. His parents insisted their son continue his education and have the same opportunities as other children.

Born in 1832, Campbell entered the first class of the newly opened Tennessee School for the Blind. He was later educated in Boston and Europe and became an accomplished musician. After completing his schooling,

he served as superintendent of the Tennessee School for the Blind. There, he pioneered new educational techniques for the blind and insisted the students become independent despite their disabilities.

He would go on to be music director at the Wisconsin Institute for the Blind and taught at the Perkins Institute for the Blind, the famed school where Helen Keller's teacher Anne Sullivan was educated. He met his wife, Sophia, at Perkins.

Campbell eventually moved to London, England, where he would help found the Royal Normal College and Academy of Music for the Blind in 1871. Campbell was the first principal of the college, which is still in operation as the Royal National College for the Blind.

He would later become a citizen of Britain and was knighted for his accomplishments in 1909 by King Edward VII. He retired as principal of the college in 1912 to return to the United States. His son, Guy Marshall Campbell, succeeded him. Campbell died on June 30, 1914.

THE SOUTH'S
FIRST BLACK MILLIONAIRE

Robert Reed Church Sr. was born June 18, 1839, in Missouri, the son of Emmeline, a slave seamstress, and a white steamboat captain, Charles B. Church, who is thought to have been Emmeline's master. As a mulatto

child born before the Civil War, Robert was not destined for a bright future. But events would change the course of the boy's life, and he would eventually become the most powerful "black" man in Memphis.

As a boy, Robert was made to work as a cabin boy and a steward on his father's boats. In 1855, the luxury steamer, *Bulletin No. 2*, burned and sank. Robert and his father were among the few who survived. The knowledge he gained as a steamboat steward would help him later to meet the personal needs of customers in a luxurious fashion when he became a hotel and restaurant owner.

Church would eventually settle in Memphis and have a family. In the horrific yellow fever epidemic of 1878, Church was able to get his family out. When they returned, they found the city decimated.

Church saw an opportunity and bought up acres of newly cheap land.

The hotel he built in downtown Memphis was advertised as the only first-class "Colored" hotel in the city. He also opened Church's Park and Auditorium for use by black citizens, who had no recreational facilities in the city.

The auditorium became the black community's cultural center and was the site of rallies of black Republicans and a speech by President Theodore Roosevelt. Before he found fame as the "Father of the Blues," W.C. Handy worked as orchestra leader at the auditorium. Other performers and speakers included the Fisk Jubilee Singers and Booker T. Washington.

The auditorium, which stood unused and neglected for many years, was eventually torn down. But the park Church created is now owned by the city and is part of the Beale Street Historic District, which is listed in the National Register of Historic Places.

In 1908, Church founded and was elected president of Solvent Savings Bank and Trust Company.

He was known as the south's first African American millionaire, although some historians now say his assets were worth $700,000.

Robert Church died in 1912. In 1994, his granddaughter, Roberta Church, donated a monument to the city to place in the park. The twenty-two-thousand-pound white granite-and-bronze monument was erected in memory of her father, Robert Church Jr., a Memphis political leader who once managed the park and auditorium, and features a bronze bust of Robert R. Church Sr.

THE GIANTS OF TENNESSEE

Tennessee is known for its hardy pioneer families, but a few of its early citizens had reputations as big as the beautiful land they settled. In fact, some would say these men were giants.

At a time when the average male was five feet, six inches tall, two men stood out: Mills Darden, who was seven feet, six inches tall and weighed more than 1,000 pounds, and

"Big Joe" Copeland, who was seven feet and three inches tall and weighed about 350 pounds. Mills Darden, whose name was often misspelled "Miles," was born in North Carolina in October 1799 to John and Mary Darden. He came with his family to Lexington, Tennessee, where he would die in June 1857.

A retrospective article in the *Lexington Reporter* on August 27, 1875, headlined "The Largest Man in the World" stated:

> *We find the following in an old scrapbook without date. Probably some of our readers know something about him: "The funeral services of Mr. Miles Darden, who died at his residence in Henderson county, was preached on the fourth Sunday in June, 5 miles southwest of Lexington, Tenn. The Masonic fraternity were in attendance, in full regalia, on the occasion. The deceased was beyond all question the largest man in the world. His girth was 7 feet 6 inches—two inches higher than Porter, the celebrated Kentucky giant. His weight was a fraction over 1000 pounds! It took over a hundred feet of plank to make his coffin; he measured around the waist 6 feet, 4 inches."*—West Tennessee Journal.
>
> *Several of his children still reside in the county, also his widow. His weight was never known, as he never permitted himself to be weighed, but was guessed to be about 1000 pounds and many of the citizens of this town and county have seen him pull an ox anywhere*

he desired which would use all its power against him. The tailor here, Mr. Pinkaton, says it took 10 yards of cloth to make a coat for him. His mode of traveling in the latter part of his life was in a wagon as nothing else could stand his weight.

Before his death, Mills, a farmer and innkeeper, had become famous throughout the world. According to the book *Every Day in Tennessee History* by James Jones, "a typical Miles Darden breakfast consisted of a dozen eggs, two quarts of coffee, a gallon of water, and 30 buttered biscuits."

Mills was married and had several children with his wife Mary, who died in 1837. Mary was four feet, eleven inches tall and weighed less than 100 pounds. The tallest of the Darden sons was five feet, eleven inches tall.

Mills's entry in the 1892 volume of *Appleton's Cyclopaedia of American Biography* stated:

Darden, Miles, giant, b. in North Carolina in 1798; d. in Henderson county, Tenn., 28 Jun., 1857. He was seven feet six inches in height, and at his death weighed more than one thousand pounds. Until 1838 he was active, energetic, and able to labor, but from that time was obliged to remain at home, or be moved about in a wagon. In 1850 it required thirteen and a half yards of cloth, one yard wide, to make him a coat. His coffin was eight feet long.

As Mills grew older, he refused to be weighed. According to legend, people who lived in Lexington guessed Mills's weight by marking the depth the wagon wheels had sunk when Mills was in it and then loading it with stones to see how many it took to match the same depth. Using this method, they recorded his weight at one thousand pounds.

Mills's tombstone said he was "aged 57 years, 3 months and 16 days." He was buried about six miles southwest of Lexington on what is now private property on Mills Darden Cemetery Road.

Joseph Jefferson Copeland, known as "Big Joe," was born in 1783 in Jefferson County, the son of Colonel Stephen Copeland, the first settler of Overton County, Tennessee, where Joe died on April 17, 1957.

Big Joe was reportedly seven feet, three inches tall and weighed 350 pounds. His wife, a Cherokee named Hannah Thatcher Ward Carrier, also was said to weigh about 350 pounds. Their children were James Richardson, Moses Wilkerson, Stephen Harrison, William Ellison, Solomon Addison, Jefferson Madison, Joseph Anderson, Louisa, Agnes, Sally and Octavia.

According to "Lend an Ear: Heritage of the Tennessee Upper Cumberland," an article edited by Calvin Dickinson, Larry Whiteaker, Leo McGee and Homer Kemp, Big Joe was known for cracking walnuts with his teeth, lifting forty-gallon kegs of brandy and lifting two hundred pounds hogs from a pen to put them on the scales. The article stated that a strong man rode a horse

from Virginia to fight Big Joe but changed his mind upon seeing the giant.

Another legend tells that Big Joe, also a legendary hunter, killed sixty-two bears one winter.

Big Joe is said to have owned most of the land in the Copeland Cove area. Some historians believe he is buried in a now unmarked grave in Roaring River Cemetery off Old Highway 42 in Overton, where he spent many hours roaming.

Of the sons who survived him, all were reportedly more than six feet tall. Stephen was allegedly seven feet, while Joseph Anderson's enlistment papers listed him at six feet four inches. William Ellison, known as "Little Ellis," would eventually weigh 360 pounds.

THE LIFE AND TIMES OF JESSE JR.

April 3, 1882, was a typical day for six-year-old Tim Howard. That soon would change. Little Tim was in the kitchen with his mother and younger sister Mary when they heard the sound of a gun blast. Rushing to the living room, Tim heard his mother scream and saw his father lying on the floor bleeding from his head. Two-year-old Mary stood nearby, crying.

Soon after, young Tim would learn his name wasn't Tim after all. And then he would learn that the man lying dead on the floor—the father he thought was John Davis Howard—was the infamous outlaw Jesse Woodson James.

Tim's birth name was Jesse Edward James, but his family called both him and his father by aliases, as the elder Jesse tried to live a respectable life on a farm near St. Joseph, Missouri. But a $10,000 reward on the outlaw's head meant the family could never relax. Jesse was shot in the back of the head by Robert "Bob" Ford, who later claimed a reward along with his brother, Charles.

Jesse Edward James was born August 31, 1875, in Nashville. He was named for his father and for Major John Newman Edwards. He would go on to live a life as varied as that of his father, although admittedly less bloody. Jesse Edward, who would always be known as Tim to his family, was at one point falsely accused in a train robbery. He was acquitted, but he decided to study law and stay on the right side of it.

He got his law degree and married Stella Frances McGowan in 1900. The couple married at his mother's farm home because she was too ill to leave it. They would go on to have four daughters: Lucille Martha, born 1900; Josephine Frances, born 1902; Jessie Estelle, born 1906; and Ethel Rose James, born 1908.

Jesse Edward took his family to Los Angeles, California, where he became a successful attorney.

Apparently, he was bitten by the acting bug, as well. After writing a book about his father's life—*Jesse James, My Father*—Jesse Edward made two films about the elder James in 1921. He portrayed his father in both *Jesse James under the Black Flag* and *Jesse James as the Outlaw*. He billed himself as

Jesse James Jr. for the films. His sister, Mary, also appeared in *Jesse James under the Black Flag.*

Following the shooting at the family home, rumors began almost immediately that Jesse James was still alive. Jesse Edward, along with his wife, Stella, would spend years trying to unmask the many imposters who came along claiming to be Jesse James.

Jesse Edward died March 26, 1951, in Los Angeles. He is buried in Forest Lawn Memorial Park in Glendale, California.

KIT DALTON: REFORMED OUTLAW

For an outlaw, Kit Dalton wasn't such a bad guy.

He became a lawman, lived to the ripe age of seventy-seven, was married to one woman for forty-five years and was a Civil War veteran, who was buried with honor in Elmwood Cemetery in Memphis. This respectable final chapter of Dalton's life was the result of his desire not to be shot or hanged like most of his outlaw brethren.

It was his promise to walk the straight and narrow path that led to his pardon from governors of several states. That allowed him to live out his life, using his real name, and to die with dignity. His obituary, printed in the *New York Times* the day after his death on April 3, 1920, stated: "He did not die with his boots on. He succumbed to an illness which extended over four years."

His headstone, erected by a Catholic organization nearly sixty years after his death in Memphis's Elmwood Cemetery, is inscribed:

> *Captain Kit Dalton*
> *1843–1920*
> *He fought for the Confederacy and with Quantrill's Raiders. After the war, he rode with Jesse and Frank James and Cole Younger over 100 years ago. A $50,000 reward was offered for him dead or alive. Since they could not capture him, he was later pardoned by several governors with his promise that he would lead an exemplary life, which he did during his last 20 years, in Memphis.*
> *Erected by Mr. and Mrs. J.D. Taylor*
> *And the Brothers of the Sacred Heart S.C.*
> *April 5, 1979*

According to Dalton's obituary, it was the devastation, wrought by Union soldiers, he witnessed in his native Kentucky while home on furlough from the Civil War that led to his downfall. He would join Captain William Quantrill and his raiders in Missouri and later organize a band of guerillas before joining the James gang. Governors from five states put a price on Dalton's head, offering $50,000 for his capture, dead or alive. He would later join a gang led by Sam Bass in Texas.

With a bounty on his head, and after many fellow gang members were shot or hung, Dalton decided to lead a

respectable life with his wife, Amanda Ellison, whom he'd married around 1875. He did so for a time, using aliases to avoid capture, but following a pardon from governors in those states that once wanted him hung, Dalton lived under his own name in Memphis.

Eight years before his death, he became a member of Central Baptist Church. In honor of his service in the Confederate army under General Nathan Bedford Forrest, he was buried in the Confederate's Rest portion of Elmwood Cemetery.

In 1950, Dalton was portrayed in a film called *Kansas Raiders.* Tony Curtis played Kit Dalton; Audie Murphy played Jesse James.

THE DEATH OF "STATES RIGHTS"

On November 30, 1864, several Confederate generals met for breakfast at a Spring Hill plantation called Rippavilla. According to legend, some of the generals etched their names in windowpanes at the home with a diamond ring. Only one etched pane remains, and it bears the name "Frank," which could belong to General B.F. "Frank" Cheatham or General Frank Armstrong.

It is unknown if another general in attendance etched his name, but S.R. Gist (rhymes with *heist* and pronounced with a hard "g") of South Carolina already was famous for his unusual name. Leading the breakfast meeting was

General John Bell Hood, who was angry that Union forces had slipped past Confederate troops the night before.

Later that day, Hood ordered what many considered a suicidal assault at Franklin. Five generals who had attended the breakfast were killed: Patrick Cleburne, Hiram B. Granbury, Otho F. Strahl and John Adams, along with one of the most famously named generals in the war: States Rights Gist.

Gist was born in 1831 in Union, South Carolina, to Nathaniel Gist and Elizabeth Lewis McDaniel Gist. In the months preceding his birth, the country and South Carolina were embroiled in a heated debate about states' rights versus nationalism. His father's political views became known when he named his ninth child—his seventh son—"States Rights." His family called him "States."

Gist was a distant relative of Continental army general Mordecai Gist and cousin to William Henry Gist, future governor of South Carolina. In 1863, Gist would marry Jane Margaret Adams, daughter of former South Carolina governor James Hopkins Adams. Gist graduated from South Carolina College and attended Harvard Law School.

In April 1862, Gist was made a brigadier general in the Confederate army. He was later assigned to the Army of Tennessee and commanded troops at the Battles of Chickamauga, Chattanooga and Atlanta. He was wounded in his hand at Atlanta.

The day after the breakfast meeting at Rippavilla, Gist was shot in the chest while leading his brigade in a

charge at the Battle of Franklin. He died of his wounds at a nearby field hospital. He was buried temporarily in a family cemetery in Franklin but was moved several years later to the Trinity Episcopal Church cemetery in downtown Columbia, South Carolina.

His name is inscribed on a plaque at St. John's Episcopal Church in Maury County, Tennessee, where Cleburne and three other generals were buried following the battle. All were later returned to their home states for burial.

E.T. WICKHAM
AND HIS OUTSIDER ART

As late as 2006, motorists in Palmyra, Tennessee, witnessed the eerie site of headless statues lining Buck Smith Road. The once-proud concrete statues were the creations of Palmyra farmer and folk artist Enoch Tanner Wickham, who preferred to be called "E.T." or "Tanner."

Since Wickham's death in 1970, the bulk of his forty statues, created in the 1950s and 1960s, have filled an area off Buck Smith Road called E.T. Wickham Stone Park. The creations include statues of himself, relatives, famous Tennesseans, religious themes and animals. Some of the more prominent people featured were Sergeant Alvin York, Andrew Jackson, Governor Austin Peay, Estes Kefauver and John F. Kennedy. Wickham also created statues of himself on a wagon pulled by a team of oxen, one of him

riding a bull and one of a World War II soldier, inspired by the death of his son, Ernest.

But weather and vandals took their tolls. Soon, many of the intriguing statues bore spray paint and nicks or were crumbling from age.

Thankfully, some historians decided Wickham's art should be preserved. Some of the works now reside at Austin Peay State University in Clarksville, while other works were cataloged for posterity at Clarksville's Custom House and Museum.

"Few residents of Montgomery County found reason to find value in the 30-plus works Wickham created between 1950 and his death in 1970, though many recall Sunday afternoon drives to visit the works or the grand annual unveilings of Wickham's latest creation," said Dixie Webb of the arts department at Austin Peay. "Only a few other works by Wickham have been preserved, while the remainder have been vandalized by rifle and spray paint."

Webb said sculptor Ned Crouch helped rescue five statues. "Ned and Jacqueline Crouch's love for outsider art led to the rescue of five works by Enoch Tanner Wickham from the unprotected and vandalized site in the country and brought to Austin Peay State University's Department of Art for restoration," she said. "Ned's expertise allowed three of the five works to be restored for inclusion in the Folklife Festival at the 1982 World's Fair in Knoxville."

The five works now at Austin Peay are:

- *Sergeant Alvin C. York*, dedicated in 1961. This statue originally was set atop a platform that remains at the roadside site.
- *Joseph holding the Christ Child*, created circa 1952–1959. The heads of this statue are no longer intact.
- *A Kneeling Child of Fatima*, created circa 1952–1959. The head is no longer intact.
- *Selma*, created after 1952. This is the representation of registered hunting dog owned by E.T. Wickham in a sleeping pose.
- *Sherry*, created after 1952. Statue of a registered hunting dog owned by Wickham's nephew Omar Wickham, in a sleeping pose.

Wickham's grandson, Joe Schibig, created a website to honor his grandfather and showcase photos of the works when they were intact. Wickham was born in 1883. He and his wife, Annie, and their nine children lived in a log cabin Wickham built.

"He was poor in income but rich in ideas and land," Schibig said.

> *He was a self-taught artist who made them out of concrete using pipes and wire as reinforcement. He used stovepipes as molds for making the pillars to the monuments. He inscribed captions at the base of his monuments. Most of the statues were placed in a row in clear view of people passing by on Buck Smith road.*

Wickham began building in 1952 when he retired as a tobacco farmer and continued his work until his death. "Building statues was hard, grueling work, especially for a man in his eighties, but my grandfather single-handedly built each of these statues," Schibig said. "Each of the larger ones took about six weeks to complete. The statue of Andrew Jackson was the most difficult one to build. Occasionally he got a little help from his grandchildren."

Wickham held dedication ceremonies for many of the statues. General William Westmoreland and Tennessee politician Estes Kefauver attended dedications of their likenesses.

Schibig considers a phrase etched in the platform of Wickham riding a bull a fitting epitaph. It reads: "Remember me boys while I'm gone."

From limestone, Wickham created the tombstones that mark his grave, as well as those of his wife and son, Ernest. He also built an angel statue, which overlooks the gravesite on the family property.

Schibig said Crouch considers the statues "to be among the top seven folk art works in the country." The Customs House and Museum in Clarksville decided in 2001 to have an exhibit of photos of Wickham's work and to publish a catalog of the works in an effort for them to be remembered. In 2006, some descendants moved the fourteen statues by the road to the nearby family property, where people can continue to view them.

Chapter 2

STRANGE SITES

PLANE, NOT PLAIN, BUILDINGS

Tennesseans have a love of oddly shaped buildings. One of the most unusual in the state is what is known as the Airplane Service Station on Clinton Highway in the town of Powell. This unique building—no longer a filling station—is in a state of disrepair despite recent efforts of a group of citizens.

A second airplane filling station that once stood in Paris, Tennessee, didn't survive.

The airplane station in Powell was built in 1930 by brothers Elmer and Henry Nickle in an effort to increase business. The station was easily recognizable to residents and a curiosity to travelers passing through town. Elmer Nickle was interested in airplanes and had the idea to

create a building in the shape of one. The body was a small store and a wing extended to create a cover for the gasoline pumps. A second wing extended to the back, forming the roof of a small room protruding from the side of the "airplane."

Sometime in the 1960s, the filling station business closed, and the airplane became a liquor store. Since that time, it has housed a produce stand, a used car business and a bait-and-tackle shop.

Three years after the Nickle brothers built their landmark, Will Dunn built an airplane station in Paris, Tennessee. Unlike the Powell station, the one in Paris was a building with an airplane shape built on its roof, as if taking off from there. It was located at the intersection of Mineral Wells Avenue and Memorial Drive. Dunn and his wife, Clarice "Sammie" Jobe Dunn, operated the station until his death in 1945. Sammie continued to operate it with her nephew, Frank Brown, and Frank's father. The landmark building was demolished in 1960 when the state of Tennessee acquired the land to widen the road.

A GUITAR FOR MUSICIANS WHO MAKE THE BIG TIME

Joe Morrell had a dream, and he was determined to make it reality. In 1983, he did. The professional guitarist and businessman built a seventy-foot-long, three-story

building shaped like a giant guitar. It was billed as "the world's only guitar-shaped music museum," according to an Associated Press article published in the *Nevada Daily Mail* on July 13, 1983.

Morrell's daughter, Anita, was quoted in the story: "Since I was a little girl, I've been seeing Dad make drawings for a guitar-shaped building." The final result took fifteen years of planning and eight months of construction. It was built of concrete blocks and plywood, with nylon ropes as the guitar's strings. Windows were hidden along the frets and in the sound holes on either side.

The museum was built to house Morrell's large collection of unusual and antique instruments, including a Harp-o-chord—a cross between an autoharp and harmonica—and instruments made of matchsticks. It also included instruments shaped like a shovel, elephant, pig and one made from an armadillo.

In 1990, Morrell purchased radio station WOPI and moved its headquarters into the Grand Guitar. His company, Morrell Music, manufactures dulcimers, guitars, mandolins, banjos and other instruments. The company also publishes songbooks in the Bluegrass Favorites, Gospel Music Favorites and American Music Favorites series. Morrell died June 19, 2006, at his home in Bristol.

In late 2010, the Grand Guitar was closed to the public for renovations. A representative with Morrell Music said the radio station still operates from the guitar, and the museum is expected to reopen.

IN MEMPHIS, GREASE IS THE WORD

Beale Street in Memphis, Tennessee, is home to many tourist attractions and famous places to eat. You can taste the difference between "wet" and "dry" pork barbecue, as strains of jazz fill the air. For those who want to eat like a local, a stop at World Famous Dyer's Burgers is a must.

It is a place visitors can actually taste Memphis's history. The restaurant opened in 1912, and Elmer "Doc" Dyer began developing what would become a secret cooking process for his burgers.

According to legend, one of the many ingredients that make up the burgers' unique flavor is Doc Dyer's cooking grease, which has been in continuous use since the restaurant opened. It has, of course, been strained. In fact, the grease is strained each day, according to Dyer's Burgers website at www.dyersonbeale.com.

One of Doc's original employees, Kahn Aaron, bought Dyer's in 1935. Whenever the restaurant has moved to new locations, the famous cooking grease has been transported under protection of armed police escorts.

In 2008, *Esquire* magazine placed Dyer's burgers on its list of "60 things worth shortening your life over." The restaurant is currently located at 205 Beale Street and is open from 11:00 a.m. to 1:00 a.m. Sundays through Thursdays and 11:00 a.m. to 5:00 a.m. Fridays and Saturdays. For information, call 901-527-DYER (3937).

BEFORE ELVIS SHOOK THE WORLD, HE SHOOK HIS LEG IN MEMPHIS

At 8:00 p.m. July 30, 1954, a show began at the Overton Park Band Shell in Memphis that would change music history. Called the Hillbilly Hoedown, the show would feature headliner Slim Whitman and a young man named Elvis Presley (misspelled "Ellis Presley" in a newspaper advertisement), who was making his first professional live stage appearance with Scotty Moore and Bill Black.

Young Elvis's nerves got the better of him, so he unconsciously did something he'd done in the studio many times—he balanced on the balls of his feet and shook his leg in time while singing, "That's All Right Mama." For what would be the first of many times, the girls in the audience went wild.

According to Moore's recollections on his website, "We didn't know what was going on when all those people started screaming and hollering." The same thing happened during "Blue Moon of Kentucky," and after leaving the stage, Elvis asked why people were screaming at him.

"Someone told him it was because he was shaking his leg, which with the baggy pleated pants created a wild gyrating effect in time with the music," Moore wrote. Elvis's trademark was sealed. He would eventually become known as "Elvis the Pelvis" and have parents convinced his hips needed censoring and girls convinced he was the man of their dreams.

The twenty-one-year-old maintained in an interview in June 1956 with the *Charlotte Observer*: "I don't care what they say, it ain't nasty." Still, the protests continued. In 1956, a judge in Jacksonville, Florida, told Elvis he had prepared a warrant to charge him with "impairing the morals of minors" unless he would agree to still his hips for that night's show.

Some historians call the concert where Elvis first swiveled the first rock-and-roll show, but at one point, the city of Memphis nearly did away with the band shell where history was made. The Overton Park Band Shell, designed by architect Max Furbringer, was built in 1936 by the city and the Works Progress Administration at a cost of $11,935.

Of the twenty-seven band shells built by the WPA, the Overton shell is one of only a handful that survives. For the first two decades of its existence, the shell was the location of Memphis Open Air Theater, which gave orchestra and musical performances.

In the 1960s, the shell became the property of the Memphis Arts Center, Inc. There was some discussion of demolishing the shell and building a theater at the site, but a petition with six thousand signatures saved it. But each new decade would bring new threats: In 1972, plans were made to raze the shell to build a parking garage. A similar plan moved forward in 1984, but a citizens group began to raise funds to save the iconic structure.

Finally, in 1986, residents formed Save Our Shell, Inc., which managed to obtain funding to save the shell and revitalize it. Since then, the organization has presented hundreds of free programs in the shell.

Renovations began in 2007, and when completed, the shell was renamed Levitt Shell at Overton Park.

It reopened in 2008, and it continues to offer free musical program for residents.

JUBILEE HALL: A REASON TO SING

In the early 1870s, just a few years after its founding, Nashville's Fisk University was in financial trouble. Established just six months after the end of the Civil War, the college was a project of the American Missionary Association and the Western Freedman's Aid Commission. It initially was run by three men—John Ogden, the Reverend Erastus Milo Cravath and the Reverend Edward P. Smith—who wanted to provide education for former slaves. The university opened as Fisk School. Its first classes began on January 9, 1866, in former Union barracks, and its first students ranged in age from seven to seventy.

But within five years, administrators were having trouble raising funds for the school.

In 1871, music professor George L. White had the idea for the student choir to go on tour to help raise funds for the school. The group, named the Fisk Jubilee Singers, sang

Negro spirituals, or "slave songs." The tour introduced the world to this traditional music and was successful beyond expectations. The singers would continue touring and would give concerts worldwide, with many famous people among the audiences.

While on tour in Europe in 1873, the singers performed for Queen Victoria. So enamored was she with their performance, the queen commissioned her court painter to create a portrait of the group. Funds raised that year were used to construct the school's first permanent building, Jubilee Hall. Today, Jubilee Hall, designated a National Historic Landmark by the U.S. Department of Interior in 1975, is the oldest structure on campus. When completed in 1875, it was the first permanent facility erected for the higher education of African Americans in the country.

The beautiful Victorian Gothic building houses the floor-to-ceiling portrait of the original Fisk Jubilee Singers, commissioned by the queen during the 1873 tour as a gift from England to Fisk. The hall is now used as a dormitory.

As is the case with many buildings of its age, the hall has been placed on the National Historic Landmark program's watch list several times. In 2003, funds were raised to reconstruct the building's steeple that was in danger of falling due to rotten timbers. Windows also were replaced.

The university's musical traditions continued throughout its history. Fisk became the first private, black college accredited for its music programs by the National Association of Schools of Music in 1954. In 1999, the

Fisk Jubilee Singers were featured in a PBS special, *Jubilee Singers: Sacrifice and Glory*.

The group continues to be a pride of Nashville, and Jubilee Hall, built by the strong voices of former slaves, remains the university's crowning jewel.

CAVE OF SECRETS

The bones of an animal that wandered into a Tennessee cave twenty thousand years ago and fell to its death are displayed in the American Museum of Natural History in New York City. The remains of this Pleistocene-era jaguar were discovered in 1939. Some of the bones were kept at the Craighead Cavern visitors' center in Sweetwater, along with plaster casts of the jaguar's tracks.

The caverns—used as housing by the Cherokee Indians, by early white settlers to store vegetables and during the Civil War to mine saltpeter—were hiding another secret, a lost "sea." In 1905, a thirteen-year-old boy named Ben Sands was exploring the cave when he crawled through a small opening three hundred feet underground and saw a huge underground lake.

While the size of the visible lake was easily determined—it is 800 feet long by 220 feet wide—researchers have yet to figure out how far the water system goes into the caverns. Named the Lost Sea, the body of water is listed by the Guinness Book of World Records as America's largest

underground lake. It is the second largest in the world, according to some sources.

Divers have entered the four-and-a-half acre lake to try to determine its end, only to find an even larger series of rooms filled with water. More than thirteen acres of water have been discovered so far, according to the Lost Sea website.

On a wall of the caverns is written the date "1863," which was carbon dated and proved to be authentic. It is believed to have been written by a soldier using the burned end of a torch.

In 1915, someone had the idea to open the caverns to the public. Often in the early twentieth century, caves were used for illicit liquor and wild parties. At Craighead Caverns, a dance floor was installed in a large upper room, while cockfights were held for entertainment in another area. Deep inside the tunnels, moonshine operations were installed.

Visitors to the caverns today will hear its colorful history from guides. At the Lost Sea, guests can take glass-bottomed boat rides onto the lake. Although it is home to some of the largest rainbow trout in North America, fishing is prohibited. The Lost Sea has been designated a Registered Natural Landmark.

For more information, call 423-337-6616.

GOOD TO THE LAST DROP

In 1869, the doors opened to one of the grandest hotels in the south: Nashville's Maxwell House.

Although it had taken ten years to complete, largely because of the Civil War, once it was open, it quickly became a place where the rich and famous came to see and be seen, including seven United States presidents.

Colonel John Overton Jr. had the idea for the hotel and named it for his wife, Harriet Maxwell Overton. In 1859, he hired architect Isaiah Rogers and, using slave labor, began construction. Before the building was completed, civil war broke out, but the project was not abandoned. At varying times, the unfinished building was used as a barracks, a prison and a hospital. Reportedly, some Confederate soldiers being held as prisoners in the building in 1863 died when a staircase collapsed on them.

The Maxwell House also was the choice of residence for ghosts. According to legend, the building was haunted by a young southern woman and two brothers who had been assigned to guard the building during the war.

A love triangle among the three would lead to tragedy. One brother was courting the girl, and the other brother, in a jealous rage, killed them both. He was then reportedly killed in the collapse of the staircase.

By this time, the structure had been known for many years as Overton's Folly. Nashvillians soon would have a change of heart. When the magnificent hotel opened in

fall of 1869 at a cost of $500,000, it was the largest in the city, with five floors and 240 rooms on the corner of Fourth Avenue North and Church Street. The entry facing Fourth Avenue was the men's entrance, and the one facing Church Street was for the women.

The hotel featured the latest in modern conveniences: steam heat, gas lighting and a bath on every floor. It included access to bars, billiard rooms, shaving saloons, a dining room and ballroom, all for only four dollars per day, including meals. Among the famous who crossed its threshold were "Buffalo Bill" Cody, Thomas Edison, Sarah Bernhardt, William Jennings Bryan, Enrico Caruso, General Tom Thumb, Cornelius Vanderbilt, Henry Ford and Annie Oakley.

Visiting presidents were Andrew Johnson, Rutherford Hayes, Grover Cleveland, Theodore Roosevelt, William McKinley, William Howard Taft and Woodrow Wilson.

In 1892, a brand of coffee, named Maxwell House in the hotel's honor, was introduced. In 1917, the company began using the slogan "Good to the Last Drop." Early ads made the claim that the phrase was coined by Theodore Roosevelt after he drank a cup of the coffee at Andrew Jackson's home, the Hermitage. The claims, however, were never proven.

The Maxwell House saw its peak in the 1890s and early 1900s. When it fell into decline, it became a residential hotel for many years. In 1961, the hotel was destroyed by fire on Christmas night.

A MIND OF HIS OWN

Driving through Haywood County, Tennessee, motorists will see huge steel girders and scrap-metal sculptures rising 125 feet into the air. They make up the *Mindfield*, the creation of Billy Tripp, an artist born in 1955 in Jackson, Tennessee. Tripp practices outsider art and wrote the book *The Mindfield Years*, published in 1996. Begun in 1989, Billy Tripp's *Mindfield* is the largest outdoor sculpture in Tennessee, and Tripp continues to add to it.

The mind-boggling sculpture located near downtown Brownsville has drawn attention to the artist, whose work has been exhibited at the National Ornamental Metal Museum in Memphis. Photos of the artwork have been displayed at the Dixie Carter Performing Arts Center and documented by the Smithsonian Institution.

Under "Frequently Asked Questions" on Tripp's website, he answers the question "Why?"

"Well, we have to do something while we're here," he says.

Upon his death, Tripp plans to be buried on the *Mindfield* property.

PIE IN THE SKY

More than one hundred years ago, a bakery was founded in Chattanooga, Tennessee. A subsidiary of the Mountain Milling Company, the Chattanooga Bakery Inc. developed

more than 150 popular snack items, such as fig bars and vanilla wafers. In 1917, perhaps its most famous brand was born: the MoonPie. Earl Mitchell Sr., a bakery salesman, was attempting to sell products in a store owned by a mining company where miners bought their groceries and other products.

According to the bakery's official history, the miners told Mitchell they needed a filling snack because they didn't have much time for breaks. Mitchell asked how big the snack should be. The bakery's website states: "A miner held out his hands, framing the moon, and said, 'About that big!'"

Upon his return to the bakery, Mitchell noticed some workers dipping graham crackers into melted marshmallow and setting them on a window sill to harden. He had the idea to add another cracker layer and coat the confection in chocolate.

The MoonPie was born. The snack soon became one of the bakery's bestsellers. In the 1930s, it became known as the treat of choice for miners and laborers, who often paired it with a Royal Crown Cola.

During World War II, the bakery shipped the sweets to soldiers overseas, and it continues to do so today.

So well known was the combination of cola and MoonPie that country music singer Bill Lister penned the song "Give me an RC and a MoonPie" in the 1950s.

But the treat was not just for workers: It soon became the choice for partygoers, too. Despite their Tennessee roots, MoonPies were chosen as the symbol of Mobile, Alabama,

because they are the signature treat of Mardi Gras, which originated in Mobile in 1703, making it the country's first such celebration, even before those in New Orleans. More than four million MoonPies are sold during Mobile's Mardi Gras season, according to Stephen Toomey, owner of Toomey's Mardi Gras Candy Company.

On December 31, 2008, the citizens of Mobile took that reverence to new heights when a six-hundred-pound electronic, lighted MoonPie was raised for the first time to ring in the New Year. Chattanooga Bakery created the World's Largest Edible MoonPie for the event, at four feet in diameter, fifty-five pounds and forty-five thousand calories.

Today, the bakery creates this "world's largest" pie for special occasions. Over the years, the bakery has created new flavors, such a banana and peanut butter, and developed a mini MoonPie.

HAVE A GIANT BURGER AND FRENCHIE FRIES AT PAL'S

Driving through northeastern Tennessee, drivers are likely to suddenly slow their cars to gawk at the giant food along the highway. The giant hot dog, hamburger, drink and "Frenchie" fries sit on top of a small building, signaling to motorists that they have arrived at one of Tennessee's most unique creations—Pal's Sudden Service drive-through restaurant.

Pal's was the brainstorm of Fred "Pal" Barger, who in 1952, while in the air force, saw a quick-service restaurant in Austin, Texas. He thought he would like to open a similar restaurant. In 1953, Barger received an honorable discharge from the air force. He obtained a degree in business in 1955 from East Tennessee State University and ran a small restaurant in Marion, Virginia, for a year, saving money for his own restaurant.

In 1955, Barger attended a restaurant convention in Chicago, where he met Ray Kroc and observed how the equipment would work at Kroc's restaurant, McDonald's. The first Pal's Sudden Service opened in 1956 in Kingsport, Tennessee.

It had a red-and-white exterior with a large neon sign advertising "Burgers, Shakes, 19 Cents." It sold mainly sauceburgers and Frenchie fries, which are specially seasoned fries. That first store is still open with the same design on Revere Street.

Barger decided on a clever marketing scheme when he built the second Pal's on Lynn Garden Drive in Kingsport. In 1962, he purchased a twenty-foot-tall Muffler Man holding a burger and installed it on the restaurant's roof. Fiberglass Muffler Men, most of which were made by International Fiberglass in Venice, California, were used to market a variety of items and often held mufflers, tires or car parts outside auto stores.

Pal's restaurants were a hit. In 1984, Pal was discussing plans for a drive-through-only restaurant with artists

Karen and Tony Barone. They sketched a building with a tiered front. On each "step" would be a giant food item—a burger, then a hot dog, then a drink and an order of Pal's specialty, Frenchie fries. The special facility was built by architect Tony Moore.

Barger continued to expand his empire. The chain now includes twenty-two restaurants in northeastern Tennessee and southern Virginia, eighteen of which have giant food on the buildings. Pal's No. 1 and No. 2 retain their original architecture, while a Pal's in Greeneville is located in a strip mall, and another is located inside Johnson City Mall.

In 2001, Pal's was presented the Malcolm Baldridge National Quality Award by President George Bush in Washington, D.C., becoming the only restaurant company to receive the award.

ROWDY NIGHTS IN KNOXVILLE

Knoxvillians were in the midst of an exciting time. With the arrival of the railroad in 1855 came a time of growth, even in the less-respectable areas of town. Into one of these areas, on Jackson Avenue in what was nicknamed the Bowery after New York's infamous neighborhood, a young Irishman would build a saloon. Patrick Sullivan, born in 1841 in Kerry County, Ireland, immigrated to the United States with his parents as a child. He was among citizen laborers who helped build a church for Irish Catholics, the Immaculate

Conception Parish, in 1855. Six years later, he would fight with the Union army as a captain in the Civil War.

Upon his return to Knoxville, Sullivan opened his first saloon, a place Irish Catholics gathered. As a young man, he built a saloon near the Southern Railway depot, which guaranteed plenty of traffic. By 1888, Sullivan had earned enough to move from the shacklike store and saloon into a newly constructed three-story Victorian building on the corner of Jackson and Central. Situated to face the corner, the red brick building was attention grabbing.

This seedy area was one not visited by respectable women of the time. It was home to saloons and brothels. Some historians believe the third floor of Patrick Sullivan's Saloon operated as a brothel.

Jackson Avenue also was an industrial shipping area, lined with warehouses filled with grain, clothing, iron ore and furniture to transport. This warehouse district had a reputation for its wild nightlife. Knoxville's *Journal and Tribune* stated in a July 8, 1900 article: "In this district is congregated probably nine-tenths of the criminal element of the city, (where) from 10 o'clock to midnight, the streets of the entire section swarm with humanity."

For almost another two decades, Patrick Sullivan's Saloon flourished and gained such a reputation that it was visited by many famous people of the time. In 1897, Buffalo Bill Cody was a guest at the saloon while touring with his Wild West Show. According to the saloon's official website, war veteran Jim Spillane tried to make conversation with

some Indians in Cody's show, but something was lost in the translation. A brawl broke out and was not contained until Cody fired his six shooters inside the pub.

In 1902, the infamous outlaw Harvey Logan, better known as Kid Curry from Butch Cassidy's Hole in the Wall Gang, visited Knoxville and was living in the city using the name William Wilson. He was a suspect in the recent Great Northern train robbery in which $40,000 in bank notes were stolen.

But Curry had little luck in lying low.

According to the Patrick Sullivan's website, Curry was drinking in the saloon one night when a brawl broke out. When deputies arrived—William Dinwiddie and Robert Saylor—they were shot to death by Curry. The outlaw soon was captured and taken to a Knoxville jail. The charming and handsome Curry was not short on visitors, particularly of the female variety. Newspapers at the time estimate as many as five thousand people visited Curry in jail to hear tales or get autographs. In June 1903, Curry escaped, riding away on Sheriff James W. Fox's horse.

In 1907, Patrick Sullivan received a crushing blow: Knoxville outlawed saloons, and Sullivan's was set to close November 1. On October 31, locals would put into motion a "jug train" and drink and party until it became illegal at midnight.

The taps would be stilled for more than eighty years.

In the interim, the once-beautiful Victorian building would be used as a boarding house, an ice cream shop, a

restaurant and an upholstery shop. It eventually fell into disrepair, but local businessman Kristopher Kendrick would rescue it in 1986 and reopen it as Patrick Sullivan's Steakhouse and Saloon.

Patrick Sullivan died in 1925, a prominent member of the Irish Catholic community.

UNIDENTIFIED FLYING HOUSE?

Across the United States, several homes specially made in the 1970s still make heads turn. They were known as "UFO" or "spaceship" houses, but their correct name was Futuro. The Futuros were prefabricated, elliptical houses designed by Finnish architect Matti Suuronen of polyester plastic and fiberglass. About ninety-six homes were built from 1968 to 1973. Visitors entered through a hatch that opened in the bottom of the disc-shaped home. The houses were portable and were considered homes of the future until the 1973 oil crisis halted production.

It is unknown how many remain now, although the homes are still in use in Illinois, Florida, Delaware, California, New Jersey, Kentucky, North Carolina, Texas and Wisconsin, and others are in Canada, Finland, Australia and New Zealand.

Tennessee has its own "spaceship house," but this one was not built from a pattern but instead is one of a kind. On Signal Mountain Boulevard in Signal Mountain,

Tennessee, is a home unlike any other. Built in 1970, the white UFO-shaped home is made of steel and concrete and has room for a car to park beneath it. Like the Futuro, a hatch opens to allow people to walk up to the first floor.

Inside are a bar and a spiral staircase leading to a main level, which is a living room, kitchen and dining area, as well as two bedrooms and baths. More steps led to a third, round bedroom. It has 1,954 square feet.

The home was sold at auction in 2009 and remains privately owned.

To see the home, take Interstate 24 exit 178 from Chattanooga, go north on U.S. 27 for four miles, exit onto Signal Mountain Road and drive northwest for three miles.

GHOSTS OF INMATES PAST

For more than a century, the facade of the Tennessee State Prison has been an imposing sight for anyone who can get near to the site off Cockrill Bend Boulevard in Nashville. The exterior features turreted towers, giving the prison a castlelike appearance.

But the story inside its walls is no fairy tale. Abandoned since 1992, the interior resembles a haunted attraction, with rusty metal bars, crumbling concrete and falling ceiling tiles. The old prison, filled with the ghosts of inmates past, still has its uses. In 1999, the exterior was filmed for the movie *The Green Mile*, based on a Stephen King novel.

According to the Tennessee Film Commission, it also was used in filming *Walk the Line*, a 2005 biopic about Johnny Cash. Also filmed at the prison were *Against the Wall*, a 1994 HBO movie; *The Last Castle*, a 2001 film; and VH1's *Celebrity Paranormal* project's episodes titled "The Warden" in 2006 and "Dead Man Walking" in 2007.

Before its closure, some scenes for *Marie: A True Story* were filmed at the prison. Starring Sissy Spacek, the 1985 film told the story of Marie Ragghianti, a parole board administrator who tried to end corruption in the Tennessee Department of Corrections. *Ernest Goes to Jail* also was filmed while the prison was still in use in 1990.

The prison's imposing design was based on the penitentiary at Auburn, New York, which was known as a place where prisoners were forced to march in lockstep, wear striped uniforms, enter solitary confinement each night and work each day in enforced silence.

The prison in Nashville had eight hundred cells that held one inmate each. Inmates were required to defray the cost of housing them with physical labor.

The prison was the site of many violent uprisings:

- During a 1902 escape attempt, seventeen convicts exploded a wing of the prison. Two escapees were never caught, and one inmate was killed in the blast.
- In 1907, several inmates crashed a switch engine through a prison gate in an effort to escape.

- Fires were ignited in several places inside the prison in 1938 in an escape attempt. One fire destroyed the main dining hall.
- In 1975 and 1985, serious inmate riots broke out.

The prison was showing its age in 1989, and recent riots gave it bad publicity. When the Riverbend Maximum Security Institution opened that year in Nashville, it spelled the end of the massive fortress. Tennessee State Penitentiary closed in June 1992. Because of its deteriorated condition, it is not open to the public.

Chapter 3

INTRIGUING INCIDENTS

THE FREAK JANUARY STORM

In Tennessee, which lies outside the traditional Tornado Alley but is not immune to the storms' terrible force, many people have heard stories of the Deep South Outbreak of 1932 and the Super Tornado Outbreak of 1974. But a lesser-known freak storm on a January day devastated a family and its community.

January tornadoes are rare for the simple reason that the air is often too cold and dry. But at 5:30 p.m. on January 14, 1932, a cool, dry front clashed with a warm, moist one and spawned a tornado that touched down near the small town of Trenton. When the winds stilled, ten members of one family would be dead.

The Rice family was living on the farm of Mrs. J. Wilbur Dickson, according to an account in a local newspaper, possibly the *Trenton Weekly Gazette*. Twelve family members lived in the home—father Percy W., forty-eight, and mother Effie D. Rice, thirty-nine, and their children, Opal, seventeen; Hazel, fourteen; Edith, nine; Horace, eight; J.R., five; Edward, four; Wilburn, six months; a son and daughter-in-law; and a grandchild, who was the daughter of the Rices' daughter and son-in-law, Mr. and Mrs. Paul McDaniel.

The newspaper account stated:

> *At the hour mentioned a cyclone approached and struck the home with such force that it was completely ripped to pieces and scattered over a wide are of territory also scattered the dead, dieing and wounded bodies of the entire family over a considerable territory…The barn on the place was torn to pieces and several fine white-face cattle were killed and others more or less crippled up and one mule was killed. The barn of a neighbor was blown down and his home slightly damaged. It is said the owner of the home, a Mr. Norvel, saw the funnell shaped could coming and carried his family out into a field and out of the path of the twister.*

All the young Rices and their parents perished. The unnamed son and daughter-in-law survived. Neighbors rushed to the scene of the tragedy, searching for little bodies among the rubble. It was too late to save them.

When the family was to be buried, a grave was dug in Mount Olive Cemetery in Dyer, wide enough for nine caskets to be laid side by side. One inset stone is inscribed with the names of Percy, Effie and little Wilburn, while small stones marking the length of the mass grave bear the names of the children and their years of birth.

Buried in a separate grave is the Rices' granddaughter, four-year-old Elsie Mai McDaniel.

WORLD'S LONGEST YARD SALE

Not many people who visit the World's Longest Yard Sale leave empty handed. From the first Thursday of each August through the following Sunday, tables filled with antiques, castoffs and treasures line highways through several states.

For many years, the sale began in Covington, Kentucky, ran south to Chattanooga, Tennessee, made a brief trip into Cloudland, Georgia, and ended in Gadsden, Alabama: a 450-mile route. In 2010, the sale extended into Hudson, Michigan, and now runs 675 miles.

The official website of the sale, www.127sale.com, states: "It's grown to be the biggest and best event of its kind in the world. You'll find homeowners selling stuff they've accumulated throughout the years as well as professional dealers and vendors. It's almost impossible for shoppers to cover the entire route in four days, so be prepared to pick up where you leave off next year!"

The sale began in 1987 when Mike Walker, a businessman from Fentress County, Tennessee, wanted to attract travelers from the interstates to the less-traveled highways. The Fentress County Chamber of Commerce, which is now the headquarters for the sale, estimates vendors number in the thousands. Coordinators do not have a record of how many visitors the sale attracts because no one has found a way to keep track.

The chamber office is located in Ye Ole Jail next to the courthouse in downtown Jamestown, Tennessee. There, visitors can purchase official 127 Sale T-shirts and throws. Chamber officials recommend bringing comfortable shoes, sunglasses, a camera and a bag to carry home treasures, as well as plenty of cash. For a map and more information, visit www.127sale.com.

THE GIANT OF MINIATURE GOLF

As early as 1916, at least one miniature golf course had been developed in the United States. It was called the Thistle Dhu (This'll Do) course in Pinehurst, North Carolina. The game was created as a children's version of golf and featured obstacles not found on regular courses, such as bridges, alleys and tunnels. In 1867, Scotland had a version of the game created for women, who, because of social norms, did not play regulation golf.

However, Tennessee can lay claim to being the "birthplace of miniature golf" because one of its residents was the first to patent the game. Garnet Carter, born in Sweetwater, Tennessee, on February 9, 1883, patented Tom Thumb Golf in 1927 and built a course atop Lookout Mountain to draw traffic to a hotel he owned with his wife, Frieda. Frieda designed the obstacles, giving them a fairyland theme.

Garnet, who created the game from his own love of golf, never expected it to become an adult sensation. He figured out a way to manufacture courses to ship across the country, still featuring elves and gnomes among its obstacles. By 1930, as many as twenty-five thousand miniature golf courses had opened around the country.

A 1931 article in *Modern Mechanics and Inventions* magazine, said it's "more than a game—it's a gigantic new amusement industry which is coining millions of dollars for the men back of it." Author Roland Gray asked:

> *Who started driving the country goofy over golf?…
> Who are the men behind this 1930 Gold Rush, that
> has sent real estate values skyrocketing and banks
> hiring extra tellers? And just one more question, if
> you please: Who are the inventors and the engineers
> responsible for the Department of Commerce's report
> the other day that there is exactly $125,000,000
> plunged into 50,000 dwarfed golf courses throughout
> the country, one of the nation's ranking industries?…
> And here's the answer. Down in Chattanooga, Tenn.,*

Garnet Carter, as genial a host as ever epitomized the hospitality of the South, began fancying a system whereby the guests at his Lookout Mountain hotel might get a little compact diversion.

In 1932, the Garnets made the decision to sell the patent rights because they had another endeavor in mind—this time an idea of Frieda's. They used the proceeds to open an attraction on Lookout Mountain called Rock City Gardens. Garnet is credited with coming up with one of history's most brilliant marketing schemes to advertise the attraction: painting "See Rock City" on roofs of barns across the South.

Garnet died at his home on Lookout Mountain on July 21, 1954. He is buried in Forest Hills Cemetery in Chattanooga.

THE UNKNOWN WOMAN BEHIND SUFFRAGE: HARRY'S MOM

Everyone knows many brave and independent women helped females get the right to vote in the United States. This is the story of a little-known suffragist, Harry Burn's mother.

By the spring of 1920, thirty-five of the forty-eight states had ratified the Nineteenth Amendment, granting women the right to vote. Thirty-six were needed. If

one more state would ratify quickly, women might have the right to vote in upcoming elections. But Delaware unexpectedly opposed the amendment. All hopes lay with Tennessee.

The Tennessee Senate approved the amendment. But House Speaker Seth Walker opposed it. The first vote in the House ended in a tie: 48 to 48. When Walker called for another vote, it was time for Harry Burn to make history.

Burn, a Republican representative from McMinn County, was listed as undecided in suffragists' polls. Political leaders in McMinn County opposed the movement. But Burn was being influenced by another party: in his pocket, he carried a letter from his mother. To help sway her son, she referred to Carrie Chapman Catt, women's suffrage leader and founder of the League of Women Voters.

It read: "Dear Son: Hurrah, and vote for suffrage! Don't keep them in doubt. I noticed some of the speeches against. They were bitter. I have been watching to see how you stood, but have not noticed anything yet. Don't forget to be a good boy and help Mrs. Catt put the 'rat' in ratification. Your Mother."

Apparently, twenty-four-year-old Harry knew better than to disappoint his mother. He voted yes and the vote was 49–48. On August 26, 1920, the Nineteenth Amendment to the Constitution became law.

All because of fifty-five words from Harry Burn's mother.

Tragedy at Dutchman's Bend

At 7:15 a.m. on July 9, 1918, people within a two-mile radius of the railroad near Nashville heard a horrific crash. They soon would learn that the sound was the splintering of wooden rail cars as they derailed and tumbled into cornfields, leaving more than 100 people dead and 171 injured. It was the deadliest train wreck in U.S. history.

The *Nashville Tennessean* reported:

> *Because somebody blundered, at least 121 persons were killed and fifty-seven injured shortly after 7 o'clock on Tuesday morning, when Nashville, Chattanooga & St. Louis Railway passenger trains…crashed head-on together just around the sharp, steep-graded curve at Dutchman's Bend, about five miles from the city near the Harding road.*

The trains that collided were the No. 4, which left Nashville for Memphis at 7:00 a.m., and the No. 1, which left Memphis for Nashville a half hour late, departing at 7:10 a.m. They met where the rail became a single track at Dutchman's Curve, where the neighborhood Belle Meade is now located. The trains were traveling fifty to sixty mph.

When the railway narrowed to one track, one train was supposed to wait on a side track as the other came through. On July 9, 1918, the No. 1 had the right of way. Because the engineer of the No. 4 was killed, no one is sure what

caused the crash, but experts speculated that the engineer thought he could beat the late-traveling No. 1 through Dutchman's Bend.

The northbound train had two wooden passenger cars filled with black workers headed to the munitions plant in Nashville. The *Tennessean* wrote under the headline "Thousands Flock to Scene of Catastrophe:"

> *Both engines reared and fell on either side of the track, unrecognizable masses of twisted iron and steel, while the fearful impact of the blow drove the express car of the north-bound train through the flimsy wooden coaches loaded with human freight, telescoped the smoking car in front and piling high in air the two cars behind it, both packed to the aisles with negroes en route to the powder plant and some 150 other regular passengers...The dead lay here and there, grotesquely sprawling where they fell. The dying moaned appeals for aid or, speechless, rolled their heads from side to side and writhed in agony. Everywhere there was blood and suffering and chaos ...From the wreckage, beneath which many still lived. shrieks and muffled cries arose, and here and there helpless yet visible victims prayed for speedy deliverance or death.*

Doctors, nurses and ambulances rushed to the crash site. For hours, bodies of the dead or injured were pulled from the wreckage and rushed to Nashville hospitals.

The Interstate Commerce Commission listed the dead at 101, though some reports listed the death toll as high as 121. The commission determined a combination of operating practices, human error and failure to enforce rules led to the crash. However, it was later determined that a change in operating schedules had the two trains meeting in a closer time frame than they typically would.

The horrific crash was commemorated in the song "The Great Nashville Railroad Disaster (A True Story)," written in the 1970s by Bobby Braddock and Rafe VanHoy. It was recorded by David Allen Coe on his 1980 album *I've Got Something to Say*.

Today, a marker at the site of the wreck tells its sad tale:

> *The deadliest train wreck in U.S. history occurred on July 9, 1918 when two crowded trains collided head-on at Dutchman's Curve. The impact caused passenger cars to derail into surrounding cornfields and fires broke out throughout the wreckage. Over 100 died, including many African-American workers journeying to work at the munitions plant near Old Hickory.*

A VOICE THAT WILL NEVER DIE

A sign posted near a boulder marking the site where a plane crashed in 1963, killing thirty-year-old country music star

Patsy Cline, reads: "Death cannot kill what never dies." But according to Margaret Jones in *The Encyclopedia of Country Music*, Cline felt an impending sense of doom and told others she would likely die young.

Patsy had been involved in two serious car wrecks, and she reportedly told friend Loretta Lynn and others that a third incident would likely kill her. Not long before her death, Patsy wrote out a will on Delta Air Lines stationary and gave away personal items to friends.

Born Virginia Patterson Hensley in Winchester, Virginia, on September 8, 1932, Patsy began entertaining neighbors at the age of three. She would eventually move to Nashville to pursue her dream of singing and would get her first break when she won an Arthur Godfrey Talent program in 1957 when she sang what would become her big hit, "Walkin' after Midnight." Her contralto voice was one of the most well known in country music history, and ten years after her death, she would be elected to the Country Music Hall of Fame.

Patsy, with her typical generosity, had agreed in March 1963 to perform at a benefit for the family of disc jockey Cactus Jack Hall, who had died in a car wreck. She would travel to the Soldiers and Sailors Memorial Hall in Kansas City, Kansas, to perform with George Jones, George Riddle and the Jones Boys, Billy Walker, Dottie West, Cowboy Copas, Hawkshaw Hawkins, Wilma Lee and Stoney Cooper and George McCormick and the Clinch Mountain Clan.

She was to return home on March 4 in a plane piloted by her agent, Randy Hughes. Patsy's close friend, Dottie West, aware of Patsy's recent preoccupation with death, had asked Patsy to ride home in the car with her and her husband, Bill, but Patsy had been anxious to get home to her children and refused.

In a strange twist, Patsy was forced to delay her trip home anyway. Bad weather forced the performers to wait for better visibility. On March 5, the Piper Comanche took off carrying Patsy, Cowboy Copas and Hawkshaw Hawkins. None of them knew they were headed into a storm.

Over Camden, Tennessee, Hughes lost control of the plane, and it crashed to the ground in a wooded area near Highway 70. Everyone aboard was killed. An article by the Associated Press on March 7, 1963, described the site:

> *Scattered debris told of the victims' background—a smashed guitar, cracked in two between the letters "Hawkshaw" and "Hawkins." A white Western belt said in black, tooled lettering: "Patsy Cline." A similar one said: "Cowboy Copas." There was fancy cowboy clothing, a pair of cowboy boots—sitting together neatly—and a guitar pick in the mud.*

People flocked to the crash site and, when the occupants became known, the country music industry went into mourning.

The Grand Ole Opry would hold a memorial concert for the stars killed, as well as for Jack Anglin, who was killed in a car crash on the way to Patsy's memorial service.

Her home state of Virginia would claim Patsy Cline, and she was buried in Winchester. Nearly five thousand people attended the service. A bell tower was later erected in her memory at Shenandoah Memorial Park in Virginia, where she was interred.

In Tennessee, mourners settled for visiting the crash site, but it would be more than thirty years before someone marked it with a boulder bearing this inscription:

> *March 5, 1963*
> *Patsy Cline*
> *Cowboy Copas*
> *Hawkshaw Hawkins*
> *Randy Hughes*
> *Lost their Lives in a Plane Crash*
> *In Loving Memory*
> *July 6, 1996*

The site can be difficult to find in the wooded area. In Camden, turn left on Mount Carmel Road past Tennessee Highway 70 and drive a little more than two miles. The monument is on the right.

JACK ANGLIN: AN ODD TWIST
TO CLINE'S DEATH

Two days following the horrific crash that killed Patsy Cline, Columbia, Tennessee native Jack Anglin, part of the country duo Johnnie and Jack, left a gig in order to attend Cline's memorial service. Anglin was driving alone when he rounded a curve in Madison, Tennessee, and lost control of his car. He was killed in the resulting crash. He was forty-six.

It was another shock for Nashville. Hearing the news, the members of the Grand Ole Opry planned a tribute to the fallen stars: Anglin, Cline and the three others aboard her plane.

Anglin was a well-respected artist. He began his career as part of the Anglin Brothers, taking inspiration from Alabama's Delmore Brothers and the Monroe Brothers. His career took off at the same time as his personal life: meeting his future wife, Louise, led to a collaboration with her brother, Johnnie Wright. Wright, who was married to singer Kitty Wells, had a radio show featuring the women, called Johnnie Wright and the Harmony Girls.

Anglin and Wright became fast friends, then partners, and found success as Johnnie and Jack in 1940. The duo performed together until Anglin's death.

Anglin was buried in Forestlawn Memorial Gardens in Goodlettsville, Tennessee. His grave marker is etched with music notes and a guitar. His wife, Louise, who died in

1983, is buried beside him. It was an odd twist that the reason Party Cline was on that fateful flight in 1963 was that she was returning from a benefit concert in Kansas for the family of a disc jockey, Cactus Jack Call, who had been killed in a car wreck.

The Murder
of the Spinster Sisters

The home of the Richards sisters was already an old house in 1940. It was gabled with a wide wraparound porch and eighteen sprawling rooms that many would call picturesque. But, because of its rambling size and because three spinster sisters lived inside, some in Oliver Springs called it "haunted."

In February 1940, the reality was much different. Two of the sisters, Ann Richards, forty-eight, and Margaret Richards, forty-six, were Sunday school teachers and members of a family that was prominent in the coal-mining community in Anderson County. A younger sister, Mary, also lived in the home.

A teenager, described in news accounts of the day as the "negro houseboy," helped the sisters with chores around the rambling home. On February 5, a Monday, the home some local children avoided would, indeed, become a scene of terror. Mary came home after leaving her job as a schoolteacher and librarian, concerned after two students

sent to take Ann and Margaret a note had returned to claim no one answered the door, and noises could be heard inside.

Mary entered through the back door and saw Ann lying in a pool of blood on the kitchen floor, according to an Associated Press report published the following day. Screaming "they've all been killed," Mary ran from the home, which got the attention of neighbors. Upon investigating, the two men found Margaret's body on the stairway landing in front of the home. A body found in an upstairs hall turned out to be that of the sisters' houseboy, Leonard Brown, sixteen, who was called "Powder."

The AP story stated: "Sheriff Robert Smith of Clinton investigated a theory that the negro youth some thought 'too timid to kill a chicken' had slain the sisters in a moment of anger and then turned the pistol on himself." Powder, orphaned and living with an aunt, was known to be shy and to know little about guns. Despite the sheriff's snap judgment against Powder, he did investigate a report of two prisoners released earlier in the day from Brushy Mountain Prison at Petros, the AP reported.

One reason the sheriff suspected Powder was because the murder weapon, a .38 revolver, was found near Powder's body. The gun belonged to a neighbor of the Richards, Gerald G. "Boss" Hannah, the public utilities commissioner. Powder had done some work for Hannah earlier in the day.

The town was split in its opinion. Some, knowing young Powder's reputation, did not think he could be the killer,

and that a mysterious stranger must be at fault. Others agreed with the sheriff's theory.

To help solve the murder, an Anderson County coroner's jury was called into duty on February 13, 1940, to hear evidence. The hearing was held in the living room of the Richards home. In attendance were Mary and her brother, Joe, the twin of Ann, who lived in another town. After five hours of testimony, the jury deliberated twenty minutes and concluded that the three victims were killed by a person or people unknown.

Tommy Diggs, who was eight years old when he was sent to the Richards house with Mary's note the day of the murders, testified during the hearing in 1940. In 2001, he told the AP: "The Richards girls were Sunday School teachers and music teachers. Everybody loved them, they were fine people. Who would have killed them except some strange person?"

For more than six decades, the mystery remained. But in November 2000, the case was reopened following a tip to Knoxville radio station WNOX. The caller stated that, on the day of the slayings, he had seen two strangers at the Richards house.

Early in 2001, Oliver Springs Police chief Paul Ray Massengill determined that Powder "was framed and the case was really a triple homicide," according to an Associated Press article. Massengill was quoted: "I am 100 percent sure that Powder Brown was a victim and did not commit suicide."

Massengill believed the real culprit had actually laid in wait for Powder for as long as ninety minutes after killing the sisters so they could frame him.

In November 2001, Massengill finally announced his solution to the mystery: A female cousin of the women had hired two men to kill them over a family land dispute. The coal-mining fortune built by the Richards sisters' father was dwindling after a luxury hotel the family built burned in 1905, but the sisters still owned land and mineral rights, over which heirs had been squabbling.

Following the murders, Mary Richards moved to Atlanta, Georgia. She died in 1994 at age ninety. Her body was returned to Oliver Springs for burial, and she was laid to rest near her sisters. A surviving cousin said she intended to use some funds from Mary Richards's estate to place a marker on the grave of Powder Brown. His marker was stolen days after his burial.

The Sinking of the *Sultana*

In May 1865, Nancy Colvin Brown mailed a letter to her husband, who had been a prisoner of war after being captured from the Union's Third Tennessee Cavalry. Nancy would write:

> *William I heard about the ship blowing up that had left Vicksburg with some prisoners in it. Oh, I made*

sure it was you. I could not tell anybody my feelings but when I got a hold of the paper and read it, it relieved me very much although I am very sorry to hear of any poor men having to suffering that way. Your mother say to tell you she like to took a jumping fit when she heard it. [sic]

The letter soon would be returned to sender: the recipient, William Laban Brown, was dead. According to a family history created by William's great-grandson, Erick Blackwell, William Brown was likely taken prisoner during the surrender of Fort Hampton in Athens, Alabama, or following the nearby battle of Sulphur Creek Trestle. A total of 971 Union soldiers, most with the Third Tennessee Cavalry, were captured on September 24 and 25, 1864. The prisoners were taken to the Cahawba prison camp near Selma, Alabama, and, at war's end, moved to a camp near Vicksburg, Mississippi, to await transport to Ohio, where they would be discharged and allowed to return home.

William was ready to get home to his wife and their five children in Knox County, Tennessee. His and Nancy's children were Mary Melissa, John Judson, William Henry, Martha Louisa and Albert Rosencrans.

At Vicksburg on April 21, 1865, William Brown crowded onto a paddle-wheel steamboat with as many as two thousand other released POWs for the trip north. He would never see his children again. Within six days, he

would be dead, along with hundreds of others following the explosion of the USS *Sultana*.

Nancy Brown did not receive word of her husband's death for weeks. When she did, the family was devastated. The Brown children were sent to the National Soldiers' and Sailors' Orphan Home in Washington, D.C. Only two—Albert and William—would survive to adulthood. The three others died of tuberculosis.

The Brown family was one of nearly two thousand that would be devastated by the tragedy of the *Sultana*.

Many believe the greatest maritime disaster in United States history was not the sinking of the RMS *Titanic* while en route to New York, which caused the loss of more than 1,500 souls, many of whom were Americans. Instead, the worst loss of life occurred seven miles west of Memphis on the Mississippi River on April 27, 1865. The *Sultana* was severely overloaded when one or more boilers exploded. Estimates of lives lost range from 1,800 to 2,400, although the official report from the United States Customs Service at the time put the number at 1,547.

Because Abraham Lincoln's assassination had occurred twelve days before the tragedy, and the newspapers were filled with details of the hunt for John Wilkes Booth and coconspirators, the sinking of the *Sultana* did not receive the media attention it might have otherwise. Many people today have never heard of the disaster. The *Sultana*, built in 1863 in Cincinnati, was meant to be used to transport cotton from Mississippi but it was frequently commissioned by the Union army to transport soldiers northward. After

leaving port in New Orleans on April 21, the *Sultana* stopped for repairs to a boiler at Vicksburg. While there, soldiers crowded aboard, ready to be discharged from their duties.

The *Sultana* had an official capacity of 376, but an estimated 2,000 were on board. On May 1, the *New York Times* reported: "Seven hundred and eighty-six of those on board the ill-fated *Sultana* have been found alive. The lost is now estimated at fifteen hundred. The Memphis hospitals are full of wounded from the Sultana, many being badly scalded and burned."

Historians now estimate about five hundred survivors reached hospitals, but of those, about three hundred would later die of their burns or exposure to the cold waters of the Mississippi. Captain J.C. Mason and the other officers aboard all were lost.

On May 28, the *New York Times* would publish a copy of the findings of an official court-martial:

When about seven miles above Memphis, the boiler, or the boilers, exploded. Soon afterward, the boat caught fire and was totally destroyed. As near as can be ascertained, only about 800 persons were saved at the time of the accident. The men were all, or for the most part, asleep. The boat was a staunch vessel and well officered. The boilers had been satisfactorily tested just before the down trip from St. Louis...The cause of the explosion, from the evidence, was by there not being sufficient water in the boilers.

Memorials to the victims of the *Sultana* tragedy can be found in Memphis; Knoxville; Muncie, Indiana; Marion, Arkansas; Vicksburg, Mississippi; Cincinnati and Mansfield, Ohio; and Hillsdale, Michigan.

Many of the dead are buried in Memphis National Cemetery.

A granite marker in Knoxville's Mount Olive Baptist Church Cemetery bears a relief of the ship's likeness. It reads: "In memory of the men who were on the *Sultana* that was destroyed April 27, 1865 by explosion on the Mississippi River near Memphis, Tenn." The names of the men are etched into its sides.

THE GREAT TENNESSEE EARTHQUAKES

Just after lunch one Christmas day, a French missionary was traveling near present-day Memphis when he felt the ground shake. His description of the phenomenon is thought to be the first written record of an earthquake caused by the New Madrid Fault.

The year was 1699.

But the most disastrous activity in the New Madrid Seismic Zone, a source of prolific earthquakes in the southern United States that stretches to New Madrid, Missouri, occurred in 1811 and 1812. The western part of Tennessee was shaken by three quakes, originating at the fault line, during these two years. They are among

the strongest in U.S. history, with the maximum intensity reaching XII, which is defined as "damage total," according to modern estimates from the U.S. Geological Society. At the time, however, the quakes caused minor damage because the area was still being pioneered and was sparsely populated. Records tell of fissures, sinks and other topographical impact, as well as chimneys falling in parts of Tennessee, Kentucky and Missouri.

The most well-known damage from the quake was the sunken land in Obion County, Tennessee, that created Reelfoot Lake. According to legend, the shallow lake was filled when the Mississippi River flowed backward for a period of ten to twenty-four hours.

Many smaller quakes have occurred from the fault since that time, and the potential remains for another series of strong quakes in the future, geologists say. Quakes from the New Madrid Seismic Zone would threaten parts of Tennessee, Illinois, Indiana, Missouri, Arkansas, Kentucky and Mississippi.

Other quakes occurring in Tennessee include the following: January 4, 1843, intensity VIII near Memphis; November 28, 1844, intensity VI in Knoxville; July 19, 1895, intensity VI in Memphis; March 28, 1913, intensity VII in Knoxville and surrounding areas; May 7, 1927, intensity VII, centered in Jonesboro, Arkansas, impacted Memphis; November 16, 1941, intensity V or VI, centered in Covington; July 16, 1952, intensity VI, centered in Dyersburg; January 25, 1955, intensity

VI centered near Finley; March 29, 1955, intensity VI centered in Finley; January 28, 1956, intensity VI struck Covington; September 7, 1956, two shocks felt minutes apart in eastern Tennessee; October 30, 1973, magnitude 4.6 main shock and more than thirty aftershocks with a maximum intensity of V shook Knoxville, knocking out power. More aftershocks occurred that December.

(Note: Magnitude is a seismographic measurement, while intensity, written in Roman numerals, describes the impact on people and structures.)

THE NIGHTRIDERS
OF REELFOOT LAKE

On January 7, 1914, under the headline "Tragic Lake Passes to Tennessee," an article in the *Atlanta Constitution* told the conclusion to a story that had begun years before. The article stated: "Reelfoot Lake, the famous fishing and game resort near the western border of the state, became the property of the state of Tennessee today."

The lake, which historians say was formed in Obion County in the early 1800s by a series of severe earthquakes along the New Madrid Fault Line, had been the scene of a battle between lakefront landowners and fishermen in the area since the early 1900s. The conflict came to a head in 1908 with the murder of a prominent man.

After a group of lakefront landowners formed a group called the West Tennessee Land Company to protect their

property and Reelfoot Lake—which they felt they owned—residents who used the lake for fishing began a campaign of nighttime barrages against the landowners. Called "nightriders," the citizens group was made up of members of families that had made their living from fishing the lake for generations. Quickly, the nightriders' attacks escalated.

On October 19, 1908, the conflict reached its tipping point: masked nightriders entered a hotel and kidnapped two men representing the land company. By the end of the night, one would be dead. The nightriders captured Colonel R. Zachery Taylor and Captain Quinton Rankin at the community of Walnut Log.

Rankin was hanged, but Taylor played dead and managed to escape. He wandered in the woods for thirty hours before arriving in Tiptonville, according to an account in the *Philadelphia Record* on October 22.

Taylor told the newspaper:

> *The leader of the mob talked with us, telling us we were associating too much with Judge Harris and were taking entirely too much interest in the lake. He said the course of Harris and the West Tennessee Land Company in prohibiting free fishing was causing the starvation of women and children, and that something had to be done.*

Taylor reported there were about twenty-five men armed with guns. The men strung up Rankin and, as he was

gasping for breath, emptied their guns into him, Taylor said. While their attention was turned, Taylor leapt into the bayou and swam toward freedom as the men reloaded and began shooting toward him. Thinking him dead, the men left.

The violence led Tennessee governor Malcolm R. Patterson to call in the state militia to maintain control. On October 28, Garret Johnson, said to be the leader of the nightriders, was arrested and confessed to the murder of Rankin. As many as one hundred nightriders were arrested. Eventually, six men were found guilty in the murder of Quinton Rankin. Although they were sentenced to death, their convictions were overturned in 1909 by the Tennessee Supreme Court.

It would take several more years before the state would acquire Reelfoot Lake and place it in the public domain for fishing and recreational use, during which time there was a truce over use of the lake.

The Nightriders of Reelfoot Lake would ride no more.

Chapter 4

TOMBSTONE TALES

WHO'S BURIED IN BONAPARTE'S TOMB

In Nashville's Mount Olivet Cemetery, visitors come across a stately looking sarcophagus made of black marble at the top of a set of steps. The sarcophagus bears the name "Vernon King Stevenson" and is a replica—with the exception of the material—of Napoleon Bonaparte's tomb in Paris, which is made of red porphyry. Inside that tomb, Bonaparte's body lies within five other coffins: one of iron, one of mahogany, two of lead and another of ebony.

The tomb may give the impression that Stevenson was a prominent citizen, which he was, and that he was loved by Nashvillians, which he wasn't. Known as the "Father of Tennessee Railroads," Stevenson helped put Nashville on the map by building the Nashville and Chattanooga

Railroad in 1848 when he was thirty-six years old. Of course, as he had purchased land along the route in the years leading up to its completion, the railroad made Stevenson a wealthy man.

He was appointed a major in the Confederate army's Quartermaster Department, but his reputation was tarnished when he abandoned his duties and fled the city on one of his trains during the Great Panic of 1862. He moved his family and belongings south but left behind many of the army's supplies.

He moved to New York in 1864.

Fifteen years after war's end, Stevenson earned the ire of Nashvillians once again when he sold the Louisville and Nashville Railroad, and it was no longer headquartered in the city. Apparently, Stevenson's impact on women also had many ups and downs: he was reportedly married four times.

He died in 1884. No explanation is given for the extravagant monument and one can only assume that, like Bonaparte, Stevenson considered himself a conqueror.

DOROTHY ANN WHITAKER: MYSTERY ETCHED IN STONE

A small stone set into the earth in Elmwood Cemetery in Memphis is one of the more mysterious gravesites in the state.

It says simply:

> *Daughter*
> *Dorothy Ann Whitaker*
> *Born Who Knows*
> *Died Who Cares*

The reason these words were carved on her tombstone is unclear, but the wording was apparently the wish of Dorothy and not her parents, James F. and Lottie M. Whitaker. Both Lottie's marker and that of her son, Gus F. Whitaker, bear dates. According to a spokeswoman at Elmwood Cemetery, Dorothy Ann made arrangements for the stone before her death, unbeknownst to her family.

Some of the mystery can be determined, however, from census records. Dorothy Ann Whitaker is listed in the 1930 census in Shelby County as the twenty-one-year-old daughter of James and Lottie. Dorothy Ann's brother, Gus, was listed as being twenty-five in 1930, and their mother, Lottie, as age forty-nine.

Lottie died in 1859, and Gus in 1986. Both are buried in Elmwood. The whereabouts of James's grave is unknown.

Dorothy Ann's death date remains a mystery.

"Let us die like men"

Patrick Cleburne was one of the most liked and respected generals in the Confederate army.

Born on St. Patrick's Day 1828 in County Cork, Ireland, Cleburne immigrated to the United States in 1849. He settled in Helena, Arkansas, and when war became imminent in his adopted country, Cleburne did not hesitate to take up arms.

His loyalty, honesty and dedication to hard work led his troops to want to give him the same in return. He never asked his troops to do anything he was not willing to do himself. He fought with bravery and gallantry, so when one of the last campaigns of the Civil War was being considered at Franklin, Tennessee, Cleburne agreed to go, despite the fact that he knew the mission was suicide.

When one of his brigade commanders surmised that few men in the unit would return home following the battle, Cleburne reportedly said, "If we are to die, let us die like men."

A few months before the fateful decision was made to send troops into Franklin and then into Nashville, Cleburne had become engaged to Susan Tarleton of Mobile, Alabama. On November 30, 1864, Cleburne led his men toward the Union fortification.

As Cleburne's troops made their assault up the Columbia Pike, the general's horse was shot from under him, and he required a fresh one. According to lore, that horse, too,

was shot, so Cleburne continued the battle on foot. He reportedly had advanced on foot to within fifty yards of the Union line when a minie ball pierced his chest.

When the battle was over, Confederates had lost thousands, among them the beloved general. He was thirty-six. He would never return to the arms of his fiancée.

Cleburne's body was found stripped of its valuables: his sword, his watch and his boots. His troops knew where to bury their commander. Just two days before his death, as his army passed St. John's Episcopal Church near Columbia, Cleburne had remarked upon its beauty. He said the churchyard reminded him of his native Ireland and, should he die in battle, he would like to be buried there.

Cleburne reportedly said: "It is almost worth dying for, to be buried in such a beautiful spot."

The church was built by Leonidas Polk, then missionary bishop of the southwest, and his three brothers, George, Lucius and Rufus. It was consecrated in 1842 by James Hervey Otey, the first Episcopal bishop of Tennessee.

Bishop Polk, who also served as a general in the Confederate army, was killed in action in Georgia in 1864. Many of the Polks are buried in the cemetery behind the church. It is also the burial site for all but one of the deceased bishops of Tennessee.

Cleburne remained buried in the churchyard for six years. In 1870, he was disinterred, and his body taken to Helena to be buried in Maple Hill Cemetery, which overlooks the Mississippi River.

DADDY BEN:
A REVOLUTIONARY HERO

In Africa, he was a prince, though his royal birth name is lost to history. When captured and brought to the colonies as a slave, he became known as "Daddy Ben," or Benjamin Scott, after his master, Colonel Scott of Tennessee.

Daddy Ben's birth date also is unknown, but it was around 1740. Not much is known about his life, but he became a legendary figure in the Revolutionary War because of his loyalty to Scott. Captured by British soldiers, Ben was threatened with the gallows if he did not disclose his master's whereabouts.

Ben refused and was hanged.

Ben also refused to die.

British soldiers tried again, twice, to hang the faithful servant. Ben, who still would not divulge Scott's hiding place, survived and was eventually released.

For his courage and bravery, he was awarded a gold medal.

As he grew older, Daddy Ben moved to Maury County, perhaps to be near Scott's daughter, who had married a Mayes. The Mayes farm was near the Zion Community of the county. He died at about age ninety on March 10, 1829, and was likely buried on the Mayes farm.

A monument to Daddy Ben, however, can be found in the Zion Presbyterian Church cemetery among its more than 1,500 graves.

It is inscribed:

> *This tablet is erected in memory and appreciation of the loyalty and service of the slaves owned by the early settlers of Zion Community. Buried here among them is Daddy Ben, a son royal prince of Africa owned by Col. Scott. His loyalty to his master won for him the award of the Gold Eagle from a British officer. He was hung three times still he refused to tell where he had hidden his master.*

THE CEMETERY PLAYHOUSE

The small playhouse looks more suited to a child's backyard than a cemetery. But in Medina, Tennessee, the house marks the grave of Dorothy Marie Harvey, who died in 1931 when she was only five years old. According to local lore, Dorothy Marie, who was born February 4, 1926, was traveling north with her parents who were looking for work. While passing through Medina, the child contracted measles and died.

She was buried in Hope Hill Cemetery in Medina. Legend says Dorothy Marie loved dolls so much that the playhouse was built over her tombstone. The interior of the house is filled with dolls and toys. The house has been replaced several times over the years, after it deteriorated or was vandalized.

What is known as the Dollhouse Grave in Medina is not the only one of its kind.

In Alabama, a brick playhouse, complete with glass windows, awnings, a chimney and a mantel inside marks the grave of Little Nadine Earles, who died December 18, 1933, of diphtheria when she was four years old. The playhouse was to be a Christmas gift from Nadine's parents. Her father had begun building it in November. Several weeks before Christmas, Little Nadine grew sick, but her gift was never far from her mind. She would say: "Me want it now" and her father, willing to offer his beloved daughter anything she wanted, promised to keep working.

Nadine didn't live to see it. When it was completed, it was placed over the child's grave in Oakwood Cemetery in Lanett, Alabama. Her marker inside the house is inscribed:

> *Our darling little girl*
> *Sweetest in the world*
> *Little Nadine Earles*
> *'Me want it now'*

The Earleses continued to fill Nadine's house with toys until their deaths. They are buried in the "yard" of the little house.

Two dollhouse graves are located in Indiana. The grave of Lova Cline is marked with a sparkling white wooden dollhouse. Lova was born in 1902 and died in 1908. Her grief-stricken father built the house to place on his daughter's grave in Arlington East Hill Cemetery in Arlington, Indiana. Through the curtained windows, dolls and miniature toys are visible.

Her parents, Mary and George, are buried in front of the little house.

Vivian May Allison, born May 5, 1892, was buried in the City Cemetery in Connersville, Indiana, after her death on October 20, 1899. The little Victorian-looking dollhouse with green trim that sits atop her grave was built by her parents. Visitors who peer through the glass windows will see a carpeted room filled with miniature furniture and dolls.

Over the years, the house deteriorated, but some benefactors helped restore it. A plaque leaning inside a window of the home is inscribed:

> *Vivian May Allison*
> *May 5, 1892–Oct. 20, 1899*
> *Constructed by her parents*
> *Horace and Carrie H. Young Allison*
> *Refurbished July 1991*

Her parents are buried nearby.

LAST WORDS: HALLELUJAH ANYHOW

Epitaphs can say a lot about a person's life—or they can leave people scratching their heads in wonder or confusion. Tennessee's many historic cemeteries are filled with interesting, entertaining and sentimental inscriptions.

The marker at the grave of Lillie Mae Glover, an award-winning blues singer who emulated the famed Ma Rainey, is an example of the thought some people give to their final words. According to an obituary published when Glover died in 1985 at the age of seventy-eight, Glover—who went by "Ma Rainey II" and claimed Rainey herself called her "Baby Rainey"—had chosen an inscription that told something of the struggles she endured as a black artist.

The obituary stated: "Paul Savarin, former owner of the Blues Alley, where Miss Glover frequently performed, said she will be buried near longtime Memphis political boss E.H. Crump in Elmwood Cemetery. Her gravestone will bear the words, 'I don't care what Mr. Crump don't allow, I'm gonna barrelhouse anyhow.'"

Glover was accustomed to bucking authority. She ran away from home in 1920 at age thirteen to sing in a traveling medicine show. She was quoted in 1982 as saying, "I wanted to sing the blues, but my father was a pastor, and the blues were looked on in those days as dirty music. And for me to stay in Nashville would have been a disgrace for my family."

She began performing as Ma Rainey II in 1939. Among her many honors, Glover was inducted into Chicago's Hall of Fame of Music and Entertainment in 1981 and received Tennessee's outstanding achievement award in 1979. She was buried in Memphis's historic Elmwood Cemetery following a funeral procession down Beale Street, home of the blues.

But when her monument was erected, it had a much different inscription than Savarin predicted. It reads: "I'm Ma Rainey #2, Mother of Beale Street. I'm 78 years old. Ain't never had enough of nothing and it's too damn late now."

Here are some other interesting epitaphs in Tennessee cemeteries, along with the other information inscribed on the tombstones:

Eyes shot out in battle of Perryville, Ky.
Oct. 8, 1862
In total darkness over 50 years
Lawyer-Soldier-Lecturer
John H. Woldridge
First Lieutenant Co. K First Tennessee Regiment CSA
September 20, 1836–July 22, 1913
Maplewood Cemetery, Pulaski, Tenn.

The End
James E. Rowe
February 6, 1938
Embury Cemetery
Shelby County

Mother
She was too good and
Pure to dwell in
This cold world

Nellie Tucker
August 28, 1871–June 4, 1949
Cook Family Cemetery, Bedford County, Tenn.

Mother
She Did What She Could
1820–1889
Mary A. Cunningham
Willow Mount Cemetery, Shelbyville

Chippy, rest easy now
Among the heavenly hosts all.
Until we can come and play with you
Ask the Angels to throw your ball.
The Chiltons' Beloved Chocolate Lab
"Chip"
February 8 1984–June 7, 1996
Pet Cemetery, Millington, Tenn.

The End of a Perfect Day
Mother and Dearie
Nancy True Bean
December 9, 1869–July 16, 1943
Memorial Park Cemetery, Shelby County

Hands at rest
His works go on
God's Youngin'

Dwight M. Archer
SP4 U.S. Army Vietnam
January 31, 1947–October 14, 2009
Memphis National Cemetery, Memphis

A Garden Variety Human Being
George Frank Caudle Jr.
November 19, 1944–May 31, 2001
Memorial Park Cemetery, Shelby County

Fair to Middlin'
Margaret Denton
His wife
March 16, 1922–September 17, 1999
Memphis National Cemetery

In the End Procrastination Ceases
Henry Dunivant
September 24, 1914–September 27, 1993
Memorial Park Cemetery

Hallelujah Anyhow
Edna Proctor
January 10, 1920–May 6, 2005
Memphis National Cemetery

I like people.
I like animals better.

But most of all I like flowers so I can share them with people.

Ellie
Eleanor A. Harwood
October 5, 1916–January 9, 2005
Memorial Park Cemetery

Please Do Not Disturb
Joseph J.L. Saucier Sr.
U.S. Navy, Korea, Vietnam
August 15, 1935–October 1, 1999
Memphis National Cemetery

Killed by Indians in Kentucky in 1785
Erected by their descendants and Rachel
Stockley Donelson Chapter DAR
Her Children Arise Up and Call Her Blessed—
April 24, 1933
In Memory of Rachel Stockley Donelson
Who lies here
1715–1794
And her husband Col. John Donelson
Born 1718
Hermitage Churchyard Cemetery, Davidson County

Darlings in Heaven

On a late March day in 1914, the weather was still cool in the hills of Maury County, Tennessee. Likely, a fire was burning in the cozy Fly home in Santa Fe, either for cooking or to provide heat to warm the family. The Flys were descendants of John Fly of North Carolina, who came to settle the area in the early 1800s and made his living as a faith healer. He deeded three and one-half acres to Goshen United Methodist Church for a burying ground. He also established the nearby Fly Community, along the Natchez Trace, and the Fly graveyard, where the first burial was of John's mother, Sarah Fly, in 1808. The depot on the rail line built through the area was called Fly's Station, and a nearby general store still owned by the family is known as Fly's Store.

Homes in the area near Goshen Church in the early 1900s were typically made of wood, and those residents with larger families and enough income lived in two-story homes. There was no electricity. No one still living remembers if sparks caused the fire in the upstairs of the Fly home on March 22, but once the blaze began, it burned out of control.

Eldridge and Jennie Wakefield Fly, who likely slept on the lower floor, made it out of the home. Their children would not.

Eldridge and Jennie could see their children in the upstairs windows as they stood on the lawn watching

helplessly. There was no nearby fire department and no water supply. When the fire had burned itself out, Eunice Fly, six, Margaret Fly, eight, and Horace Fly, eleven, were dead.

The fire had a lasting impact on the small community. Fannie Blackburn, whose nearby farmhouse had two floors, put a roof over her front porch and installed windows above it so anyone trapped by fire could climb out. Many others simply had their children sleep on the first floor. Any new homes built had only one floor.

The Fly children's grave has since become legend. Children attending picnic dinners at Goshen Church create tales about the headstones in the adjoining cemetery, marking tragically short lives. The Fly children were buried in one grave beneath a triple stone, each marked with the name, birth and death date of one of the three children: Eunice, born October 2, 1907; Margaret, born August 30, 1905; and Horace, born August 19, 1902.

The inscription reads: "Our darlings together in Heaven."

THE DEADLY STUBBED TOE

Jack Daniel is one of the most well-known names in the country. But not as many people know Jasper Newton Daniel, which was Jack's birth name.

Jack was famous for the whiskey he created and, today, Lynchburg, Tennessee—home of the distillery—is a popular tourist destination. Jack died on October 10, 1911. He was born sometime around 1846, one of thirteen children of Calaway Daniel and Lucinda Cook Daniel. The records of his birth were destroyed in a courthouse fire. Jack's method of death would only add to the distiller's legend. The oft-repeated story, which is told on distillery tours, states that Jack arrived at work early one morning and attempted to open his office safe. He had problems with the combination and could not manage to open it. In frustration, he kicked the solid, metal safe, breaking his toe.

An infection set in, causing gangrene. Over time, Jack succumbed to blood poisoning. The offending safe remains at the distillery and also is shown on tours. The running joke is that the moral of Jack's story is, "Never go to work early." According to legend, his last words were "One last drink, please."

This unusual death was portrayed on Spike TV's show *1,000 Ways to Die*. Jack is buried in Lynchburg City Cemetery. Two chairs are set on either side of the headstone, reportedly so the many local women who mourned his passing would be comfortable.

JANE BROWN:
KIDNAPPED BY INDIANS AND SURVIVED

In quiet, historic Greenwood Cemetery in Columbia, an eroding box tomb is a link to the state's violent past and to a woman who was one of its pioneers. It is the final resting place of Jane Gillespie Brown.

Her adventure to Tennessee began in the late 1700s when she and husband James were among those traveling westward from North Carolina to settle new lands. They took their brood of children and stopped at a site along the Tennessee River, knowing this wild, new territory was dangerous but unaware that their fate would become part of Tennessee lore.

James Brown, according to Brown family genealogy, was born around 1735 in Ireland to William Brown and Margaret Fleming. The woman James would marry, Jane Gillespie, was born June 22, 1740, in North Carolina to Patrick Gillespie and Ann Denniston.

James established himself as a respected resident of Guilford County, North Carolina. He left his ever-growing family to fight in the Revolutionary War, initially working as a guide to General George Washington. He later fought under Washington against the British forces of Lord Cornwallis, doing his part to secure the independence of America.

An account written about James in the *American Whig Review* in 1852 states: "For his revolutionary services he had

received from the State of North Carolina land-warrants, which entitled him to locate a large quantity of lands in the wilderness beyond the mountains."

Although James was made sheriff and a court justice in North Carolina, the call of the wild lured him, the journal stated. "He readily saw the advantages which he might secure to his rising family by striking out into the deep forests, and securing for them the choicest homes in the Tennessee and Cumberland valleys."

Tennessee was largely unsettled with a few exceptions, including the Nashville area, and Brown took his two oldest sons to explore the region before bringing the remainder of the family. They explored along the Cumberland River and as far as the Duck River in what would become Columbia. These were rich, fertile lands and the hunting grounds of Creeks, Cherokees and Chickasaw Indians.

James left his sons behind to build cabins for the family and returned to North Carolina to get his wife and other children. Some family genealogies claim the couple had as many as fourteen children—the *American Whig Review* states there were nine children—but most accounts agree that seven children started this westward trip.

The seven children listed in a family genealogy are: Ann Brown (circa 1765–1839), Margaret (circa 1762–unknown), Daniel Brown (circa 1767–May 9, 1788), William (mid-1760s–circa 1835), George Brown (circa 1769–unknown), John (circa 1771–May 9, 1788) and Joseph (1772–1868).

By 1787, the Brown family had made camp on the banks of the French Broad River in Hawkins County, waiting for spring before continuing the trip into the Cumberland Valley. When the time came, James chose to have his family travel by boat along the Tennessee, which had proven to be a shorter but more deadly route because of the Indian villages along it.

The journal stated: "Having been habitually exposed to danger for many years, it is probable he rather sought the most perilous and dangerous route, feeling a sort of manly desire to meet and overcome it." On May 9, 1788, just as members of the party thought they had passed through the most dangerous portion of the river, they were confronted by a party of Cherokees near Nick-a-jack Cave.

James, trying to protect his family, was attacked and died after being nearly beheaded. His body was thrown into the river. In the papers of surviving son Joseph, he describes the scene:

> *Before they had finished robbing the boats, however, a dirty, black-looking Indian, with a sword in his hand, caught me by the arm and was about to kill me, when my father, seeing what he was attempting, took hold of him and said, that was one of his little boys, and that he must not interrupt me. The Indian then let me go, but as soon as my father's back was turned, he struck him with the sword, and cut his head nearly half off.*

Jane Brown, her ten-year-old son and three small daughters were taken by a party of braves who had participated in the raid of the white family, while her son Joseph was taken elsewhere. The oldest sons, who had explored the territory with their father, were killed.

Jane and her children were forced to march many miles, by some accounts two hundred, to an Indian village. Some were kept in captivity for about a year; the young boy was held for five years. Joseph was kept for seventeen months.

The surviving children went on to lead normal adult lives, and in 1792, Jane settled near Nashville with her son, Colonel Joseph Brown, who would become a Cumberland Presbyterian minister, according to the *National Intelligencer* in 1831.

Jane would later move to Maury County. She lived to be ninety years old. Her remains were initially buried in the Old City Cemetery south of Columbia, but she was later reinterred at Greenwood. Beside the aging slab is a marble replica with the original inscription, erected by Daughters of the American Revolution.

It reads:

> *Sacred to the memory of the widdow Jane Brown who departed this life the 4th day of June, 1831, aged near 91 years as she was born 22nd June, 1740. She was 71 years a member of the Presbyterian Church & died in the triumph of a living faith. Her husband,*

James Brown, Esqr. was murdered by the Cherokee Indians on the Tennessee River, the 9th of May, 1788 with two of his sons and 5 other young men, and his wife and five children were taken prisoner. Some of them got back to the white settlement in one year, others longer, and one was five years. O Reader, these…people lost their lives and liberty in obtaining this good land that you enjoy. O be ready to leave and go to the good world.

A LIGHT IN THE DARKNESS

Unique tombstones have a way of breeding legends, whether they have basis in fact. One such grave in Nashville City Cemetery is marked with a large limestone boulder and a plaque inscribed: "Ann Rawlins Sanders 1815–1836." Atop the boulder is embedded a metal holder and a lantern.

According to legend, the woman who is buried beneath the boulder committed suicide after a quarrel with her fiancé. It was her love who placed the boulder on her grave, adding an iron lantern that he would light at night because Ann was afraid of the dark. Another legend states the boulder is a piece of the cliff she jumped from into the Cumberland River.

The truth is much less romantic but no less tragic. Ann Sanders was a devout Presbyterian who married Charles

H. Sanders in 1832. Records do not tell how she died at the young age of twenty-one, but an obituary published on April 1, 1836, in a Nashville newspaper describes the kind of woman she was:

> *On the night of the 30th of March, about twelve o'clock, a soul of bliss winged its way to mansions on high. Too pure longer to remain here below, it returned to its maker, after a sojourn among us twenty-one winters. By redeeming grace was made as pure as 'twas first given. Mrs. Ann Sanders, consort of Mr. Charles H. Sanders, was a woman whose piety made her celestial among mortals. She was a happy representative of the Church. Her lovely expression was as a magnet to the lukewarm and the skeptic. In her the Church have lost its brightest ornament, the poor their kindest friend, society its strongest prop.*

The plot where she was buried was owned by Edward Steele, who may have been Ann's brother-in-law. Reportedly, she is not buried beneath the rock, but in a nearby box tomb.

Two mysteries remain: What is the reason for the boulder, and why was the lantern placed on top? The mystery may be the basis of legend for another 170 years.

A Tribute
for Little Mary Holeman

Little Mary Vanhook Holeman, who died in 1862 before she could celebrate her second birthday, not only had her grave moved to make way for modern construction, but for many years, it was missing her headstone as well. In 2003, Liz Welling of Middleton, Tennessee, found a white marble headstone resting against a tree deep in the woods. It featured the relief of a resting lamb and was inscribed:

> *Mary Vanhook*
> *Dau. Of Rebecca F. & Tom Holeman, Jr.*
> *Born*
> *Oct. 29, 1860*
> *Died*
> *June 30, 1862*

Welling did some research, hoping to find where the stone belonged and return it to the little girl's final resting place. She had no luck. When she moved to Houston, Texas, years later, she decided to take the monument with her. In 2009, she tried again to research the child's name. Finally, she found a reference to little Mary. In the intervening years, someone had posted a listing of those buried in the Walker family cemetery, including Mary Holeman, whose mother's maiden name was Walker.

Those buried in the cemetery, which ended up as the property of the Memphis-Shelby County Airport Authority, had been moved in 1980 for an expansion of the FedEx facility. The dozen or so gravesites moved to Elmwood Cemetery in Memphis included those of Mary Vanhook and her mother, Rebecca Frances Walker Holeman, who died at the age of twenty-four in 1861, just five months after her daughter was born. Each was buried in numbered plots, and records show where each gravesite is located.

No one knows how little Mary's headstone came to be in Middleton, about an hour and a half drive from Memphis. When Welling discovered the Walker cemetery stone had been moved to Elmwood, she contacted Elmwood caretakers, who were excited to hear about the discovery. The marker was mailed to the cemetery, and preservationist Todd Fox began work to place it back on Mary's grave. It was broken from its base but the stone was not cracked, so Fox was able to cement the stone onto a new white marble base, which was donated by Vicky de Haan of Crone Monument Company

Welling is quoted on the Elmwood Cemetery website: "Mary's father lost his wife, then baby and obviously loved her very dearly to commission so lovely a tribute during such an incredibly hard time. His objects of affection are reunited at last."

HE DREAMED THE PARTHENON; WAS BURIED IN A PYRAMID

Eugene Lewis was a dreamer but one who tended to make dreams a reality. When he was named director general of the Tennessee Centennial Exposition held in Nashville in 1897, the chief civil engineer for the Nashville, Chattanooga and St. Louis Railroad had an idea: build a replica of ancient Greece's Parthenon to showcase Nashville's reputation as the "Athens of the South."

The Tennessee Centennial Exposition opened May 1 and entertained 1.8 million visitors over the course of six months. The Parthenon was the centerpiece of the exhibit, which also included a pyramid, but unlike the Parthenon, the pyramid was meant to be temporary, to last only as long as the exposition.

Following the exposition, the grounds were converted to Centennial Park, a permanent city park with the Parthenon at its center. The wood-and-plaster replica remained until 1920, when it was rebuilt with concrete. Lewis was an original member of Nashville's Board of Park Commissioners and worked to create Centennial Park as a Nashville showpiece, as well as Shelby and other parks. A photo of him hangs inside the Parthenon in a pictorial display of the exposition.

Lewis, born in 1845, also was a force behind Nashville's Union Station, built in 1900.

When he died in 1917, he was buried in a pyramid-shaped crypt guarded by stone sphinxes in Nashville's Mount Olivet Cemetery. The sphinxes guarding the crypt are each about three and one-half feet tall and are set on the short path leading to the pyramid. Set into the side of the crypt is a triangle-shaped plaque placed there by Lewis's children. It is inscribed, in part, "in loving memory of our honored father…a man who posterity will know and honor by his good works. He gave freely of his talents that his fellow man might enjoy more abundantly God's great gifts of nature."

A CURMUDGEON'S LAST WISH

On his death, prominent Memphis citizen Wade Hampton Bolton was known for his philanthropy. He was a benefactor to the Bolton School and Stonewall Jackson's widow. But in life, Bolton was, by all accounts, a man who earned little affection.

The Bolton family was embroiled in a notorious ongoing feud with the Dickens family. Both families were slave traders, and the feud began with a business dispute. Not surprisingly, a feud over the ownership of human beings led to violence and the deaths of as many as eight people. Wade Bolton would not survive the feud. In 1857, after a man named James McMillan refused to refund money on a slave sold to the Boltons, who turned out to be a freedman,

Wade's brother Isaac shot and killed McMillan. Isaac claimed self defense and was acquitted, according to the 1887 book *Goodspeed's History of Shelby County.*

On July 14, 1869, Wade H. Bolton was shot and killed by Tom Dickens at Memphis's court square. Dickens was arrested and put on trial but he was found not guilty. A year later, Dickens, too, was murdered.

Wade Bolton's true nature is evident in the terms of his will. It contained eighteen clauses, a few of which are quoted here from www.memphishistory.org:

> *I give and bequeath to Seth W. Bolton $5,000, provided he lends an assisting hand and helps to defeat the gigantic swindle of old Tom Dickens and his tool, Sarah W. Bolton, has instituted against her father's estate and mine. In event Seth W. Bolton be married or does marry a white woman of his own choice, the $5,000 shall be invested in a piece of land for them. But if Seth W. Bolton remain in a state of celibacy which he is likely to do, my executor is instructed to loan the $5,000 and pay him the interest annually…I give and bequeath to my niece, Josephine Bolton, now wife of the notorious Dr. Samuel Dickens (the Judas of the family) $5, one sixth of what Judas Iscariot got for betraying the Lord. Poor Jo, her cup of iniquity will be full after while if she ever gets time to stop in her mad career, trying to help swindle her sister out of her money, and will let her mind reflect back upon*

*her childhood days when she sat under the shade trees
and roof of her father and saw the streaming tears
and heard the bitter sobs of her father and her mother
portraying in the ear of her father that some distant
day that old Tom Dickens would swindle them out of
all they had and bring them to want. The prophecy is
fulfilled in 1868 and her daughter is lending a helping
hand...I give and bequeath to the widow of Gen. T.J.
Jackson, who fell at the battle of Chancellorsville,
$10,000.*

Bolton gave land and an endowment that was used to found Bolton College. Bolton High School still remains on the property. It is the state's only public school with its own endowment. The terms of Bolton's will also stated he wanted a statue on his grave that depicted him as he was in life.

His family complied. On the beautiful grounds of Memphis's historic Elmwood Cemetery stands a life-sized statue of a man, scowling down at visitors, with his fingers crossed behind his back, his vest buttoned incorrectly and his shoes untied.

FASTER, HIGHER, STRONGER

Wilma Rudolph's legacy as "the fastest woman in the world" lives on in her hometown of Clarksville, where a

bronze statue of Rudolph, crossing an imaginary finish line, reminds residents of one of its most prominent citizens. Rudolph's gravestone will help ensure that legacy continues into the future: the contemporary black granite stone is inscribed with a list of the track star's many accomplishments, including her three Olympic gold medals.

Rudolph, who is buried in the cemetery at Edgefield Missionary Baptist Church in Clarksville, died November 12, 1994, at her Brentwood home of a brain tumor. Her marker, which is etched with her likeness and three gold medals hanging from the Olympic rings, bears the words *Citius Altus Fortius*, the Olympic slogan that means "faster, higher, stronger."

Among achievements etched down one side of the geometric marker are her induction into the Black Sports Hall of Fame, the National Track and Field Hall of Fame and the U.S. Olympic Hall of Fame and her recognition by the NAACP Image Awards. And all these honors were achieved by a child born prematurely and who was stricken with polio when she was very young.

Rudolph was born June 23, 1940, the twentieth of her father's twenty-two children. During childhood, she would suffer from polio, scarlet fever, whooping cough, chickenpox and measles. She wore a brace on her leg and foot, but with the help of physical therapy and regular leg rubs from her many siblings, little Wilma vowed to one day play basketball like her big sister.

When the braces came off, Rudolph wanted nothing more than to run. By the time she was sixteen, she was an all-state basketball star and had won a bronze medal in the relay in the 1956 Olympics in Melbourne.

She received a track scholarship in 1957 to Tennessee State University, where she would set the world record for two hundred meters in July 1960. But it was at the 1960 Olympics in Rome that Rudolph inspired a nation. She was the first woman from the United States to receive three gold medals in one Olympics, winning in the one-hundred- and two-hundred-meter races and the four-by-one-hundred-meter relay.

Rudolph would go on to be one of five sports stars selected as America's Greatest Women Athletes by the Women's Sports Foundation. In Clarksville, she remains the hometown hero.

Chapter 5

ODD OCCURRENCES

A True "American Haunting"?

In 2006, when the film *An American Haunting* opened in theaters, Tennesseans flocked to see it. With huge stars attached—Sissy Spacek and Donald Sutherland—and a larger-than-life Tennessee legend behind it, people were curious. Would the story be accurate?

The film told a version of the famed legend of the Bell Witch, which many in Tennessee guard closely. It is the most documented incident of a haunting and marked the only time in history a man's death was attributed to a spirit. The legend of the poltergeist that tormented the Bell family of Adams, Tennessee, is widely known, and the movie brought it into the limelight once

again. But the film was disappointing to historians and "keepers of the legend." Based on the novel *The Bell Witch: An American Haunting* by Brent Monahan, rather than any of the dozens of nonfiction accounts, the film version gave an explanation for the spirit's tormenting acts: Elizabeth "Betsy" Bell had been sexually abused by her father, John, and used the "witch" as a way of responding to it.

Historians have found no evidence that John molested his daughter. Also, the film implies John Bell was killed by Betsy, and that her mother was complicit in the act. This, too, was not part of the original legend. According to historical accounts, John Bell's life slipped away over the course of three years, as the constant torment from the entity impacted his health.

The "haunting" of the Bell family began in the early 1800s on their farm in rural Robertson County, along the Red River. Because the strange occurrences began not long after John Bell had a dispute with a neighbor named Kate Batts, the haunting was believed to have been instigated by Kate, who was labeled a witch. Beginning in 1817, a sinister entity tormented the Bells, but particularly John and his daughter, Betsy, one of his eight children. Until 1821, the attacks continued— pulling hair, kicking, slapping, yanking off bed covers— witnessed by many people in the community and recorded in affidavits and journals. John, born in 1750, would die in 1820.

Betsy, born in 1806, would live until 1888, but she would give up her first love to the strange entity. Because the witch showed disapproval of Betsy's fiancé, Joshua Gardner, she broke off her engagement and eventually married her schoolteacher, Richard Powell. They would have eight children.

Before he became president, Tennessee native Andrew Jackson, a friend of the Bell family, was asked to come to the farm. He took a group of men to test the rumors, and the men were confronted by strange happenings. Jackson's reaction is one of the legend's most quoted, though the phrasing varies: "I would rather take on the entire British Army than stay another night at the Bell house." The events that occurred on that visit are documented in *An Authenticated History of the Famous Bell Witch*, written by M.V. Ingram in 1894.

The many eyewitness accounts and testimonials led a famed parapsychologist of the early twentieth century, Dr. Nandor Fodor, to label the legend "America's Greatest Ghost Story."

Perhaps that is what filmmakers hoped to capitalize on with *An American Haunting*. They used film sites in Romania and Quebec to double as rural Tennessee in the early 1800s. The tale was bookended by a modern tale of a young girl, who—it is discovered—is being molested by her father. The year before the big-budget *An American Haunting* was released, independent filmmakers made *The Bell Witch Haunting*. In 2007, a film called *Bell Witch: The Movie* was

released. It was filmed in Townsend, Tennessee, and was based on the original legend.

Despite mostly negative reactions to *An American Haunting*, the town of Adams embraces the Bell Witch and any vehicle that adds to her fame. She is now a major tourist attraction in the town of about six hundred souls. The town's welcome sign features the silhouette of a traditional witch wearing a black cape and pointed hat and riding a broom.

In Bellwood Cemetery stands a memorial to the Bell family that is inscribed:

> *John Bell 1750–1820*
> *And His Wife Lucy Williams*
> *Pioneer Settlers from*
> *Halifax and Edgecombe Counties*
> *North Carolina*
> *Whose Farm Included the Land Hereabouts*

Betsy is buried in Long Branch Cemetery in Yalobusha County, Mississippi, where she lived with her husband. Her headstone is inscribed:

> *A Love One Have Gone From Circle* [sic]
> *We Shall Meet Her No More*
> *She Has Gone to Her Home in Heaven*
> *And All Her Afflictions are Over.*

The Bell Witch Cave, which is near the property where the Bell farmhouse once stood, is open for tours. The owners built a cabin resembling the one thought to be used by the Bell family, which houses some artifacts from the home, such as a chimney stone and an iron kettle. According to the cave's owners, Kate Batts haunted this cave, and strange occurrences happen there to this day.

For information on tours of the Bell Witch Cave, call 615-696-3055.

THE BLOOD-STAINED MAUSOLEUM

The beautiful and historic St. Luke's Episcopal Church is a landmark in Cleveland that has been the site of many happy events. But its origins lie with one of the city's most tragic families. The church was an 1872 gift to the city from John Henderson Craigmiles and Myra Adelia Thompson Craigmiles in memory of their daughter, Nina.

Nina was born August 5, 1864. Several historic accounts say she enjoyed riding by horse and buggy. On October 18, 1871, when Nina was seven years old, she went on a buggy ride with her maternal grandfather, Dr. Gideon Blackburn Thompson. It was St. Luke's Day. Some reports state Dr. Thompson had the reins that day, while others claim Nina was allowed to drive the buggy and was traveling too fast. Inexplicably, the buggy crossed railroad tracks in town just as the train approached. Dr. Thompson

was thrown clear of the wreckage and survived, but little Nina was instantly killed.

Nina's tragic death shocked the town's residents, but it is said no one grieved as deeply as her father, who adored his little girl. The first request recorded in his will stated: "I wish to very plainly be buried in the lower-hand catacomb in the vault or mausoleum where sleeps the ashes of our darling little Nina."

The Craigmiles were a prominent Cleveland family who attended the Episcopal church. Before Nina's death, members of the congregation met under the name St. Alban's Church and, not having a building of their own, met in the Presbyterian church building. John Craigmiles decided to build an Episcopal church in Nina's memory. No expense was spared. In the churchyard, the Craigmileses constructed a mausoleum of carrera marble that cost nearly as much as the cost of building the church. It would house Nina's remains and be available for future Craigmiles family burials.

A legal document published in the 1900–1901 edition of the *Southwestern Reporter*, which recorded decisions of the Tennessee Supreme Court, stated:

> *That October 18, 1871, Nina Craigmiles, then about seven years of age, the only child and daughter then living of respondent and the testator, was accidentally killed; and in her memory the testator and respondent in 1872 erected a church, to wit, St. Luke's Memorial*

Episcopal Church in said town of Cleveland, and two or three years later constructed a marble mausoleum for the purpose of containing the remains of their child and of themselves after their death—said two structures costing between $40,000 and $50,000.

Upon its completion, the church was named St. Luke's Memorial Episcopal Church in Nina's honor. It was consecrated on St. Luke's Day in 1872. On October 17, 1878, the *Weekly Banner* newspaper reported: "Tomorrow is memorial services at St. Luke's Church—it being the anniversary of the death of NINA CRAIGMILES, which occurred seven years ago. The public generally are invited to attend."

The official church history states the building is one of the few Oxford Movement Gothic churches in the world to maintain its integrity. The only additions over the decades have been electricity, air conditioning and heating. The building's original three-story bell tower houses a sixty-one-bell carillon that has sounded through the city for 130 years, giving the time and calling people to worship. It also is used to commemorate historic moments, such as during wartime and on September 11, 2001, after the terrorist attacks. The church has been featured in numerous books and articles on architecture.

The mausoleum also is an architectural prize with its Gothic spires and statues of angels holding lambs and crosses. Above the metal doors is etched: "J.H. Craigmiles." On the doors are the words: "Nina, October 1871."

Nina's remains lie in a marble sarcophagus in the center of the mausoleum. A fringed blanket, topped with a crown and cross, is carved atop it. Along its side, among a carved ivy drape, is etched: "Born August 5, 1864. NINA daughter of M. Adelia and John H.E. Cragmiles. Fell asleep October 18, 1871."

The family soon would see more tragedy. Another tomb inside the mausoleum bears no name other than "Infant Son" and the date November 1873. The infant lived only a few hours.

John Craigmiles would join his beloved Nina in heaven in 1899, after succumbing to blood poisoning from an injury he sustained in a fall on an icy city street. Adelia lived nearly three decades more, but her death, too, would be shocking. At the age of eighty, she was struck by a car while crossing a Cleveland street. Although she had married again to a man named Charles Cross, she, too, is entombed in the Craigmiles mausoleum. Continuing her first husband's benevolence, she established the Myra Adelia Craigmiles Cross scholarship for students in need at Sewanee, the University of the South.

The Craigmiles mausoleum is a tourist attraction in Cleveland today not only for its architectural beauty but also for the eerie mystery surrounding it. At some point following Nina's entombment, red stains appeared on the white marble exterior of the mausoleum.

Efforts to remove the stains failed. According to legend, the stained marble blocks were replaced several times, but

the red stains always returned. As is the case with many sites linked to tragic deaths, reports of supernatural sightings at the crypt are common. Some say they have seen a little girl in 1800s attire playing in the area.

Today, the blood-red stains are visible on the mausoleum, another testament to the impact made on local history by a little girl taken too early from this world.

THE LEGEND OF BOOGER SWAMP

What once was a large and dismal swamp just east of Cookeville gave rise to a legend that cost a preacher his faith. In the 1850s, a minister, whose name was not recorded, was riding his horse along the road that dissected the marshy area that was about eight miles long and two miles wide. The swamp followed the path of what is now Highway 111.

Through the darkness, the minister witnessed a terrible sight. Upon his arrival back in town, he would describe "a pure white body floating about a yard above the ground," author Walter S. McClain wrote in the book *A History of Putnam County, Tennessee*, in 1925. The apparition, the minister said, tried to communicate, but the minister's horse became spooked and ran away.

According to some accounts, the apparition was headless. Because "spooks" were not part of the church's beliefs, congregants tried to get the minister to retract his story. He

refused. He stood by the details of his story. The minister was tried in a church court and expelled from the ministry for consorting with evil spirits.

The swampy area was thereafter known as Booger Swamp. People began to avoid the swamp, but those who did not, including hunters and couples who wanted a private spot to court, would report hearing strange sounds or seeing eerie apparitions. At times, hunting dogs would come running from the woods, yelping in fright.

One legend claims the apparition is the ghost of an Indian maiden whose young brave was killed on a hunting trip. She is said to have been hunting for him through eternity.

Over the years, people have claimed to see the ghost of a Civil War soldier. After the film the *Legend of Boggy Creek* was released in 1972, people reported seeing a hairy beast that walked upright in the swamp. That report led to a belief that a Bigfoot lived in Booger Swamp. Today, development has filled in much of the swampy area, but legends persist: what kinds of creatures lurk in the depths of Booger Swamp?

Signs?

It was an odd sight that greeted Captain Bryan Graves of the Monroe County Sheriff's Office as he looked down on Madisonville from his small plane in June 2007. In the

wheat fields below, he noticed flattened stalks created a pattern of circles: one large circle orbited by smaller ones in a pattern described as a Celtic cross.

Investigators on the ground discovered the large circle was 170 feet across. When the farmer was contacted, he said he had not witnessed anyone in the fields and was unaware the circles were there. The incident could have been considered vandalism, but because the landowner

did not file a complaint with the sheriff's office, no formal criminal investigation was conducted.

That didn't stop curiosity seekers and conspiracy theorists from flocking to the site. Other than kids committing vandalism, theories of how the circles appeared ranged from ancient Cherokee Indian curses to natural electrical or atmospheric disturbances to space aliens.

One group, the Independent Crop Circle Research Association, concluded the circles were not manmade. After taking more than 1,500 samples from the site, the researchers concluded that the wheat showed evidence of application of heat of the type produced by microwaves. Finally, the landowners erected No Trespassing signs to keep the curious away.

Since then, a few people reported seeing strange lights in the sky above the quiet town of about four thousand souls. In May 2008, another formation appeared in Monroe County. This time, circles were formed at the three points of a triangle. Again, the landowners heard no evidence of humans in the field. The landowner said he believed the circles were not manmade.

Crop circles are not a new phenomenon. They have appeared in many countries around the world in fields of wheat, barley, rye or corn. In September 1991, two Englishmen in their sixties, Doug Bower and Dave Chorley, went to the media and claimed credit for the crop circle phenomenon. They said the circles began as a prank in the late 1970s and continued when people began to speculate

the circles were the work of extraterrestrials. The men said they used wooden planks and string and demonstrated their work for television cameras.

However, skeptics claim that it would have been impossible for Bower and Chorley to have created the hundreds of patterns to appear in the fields of England during the peak of circle activity. And what of circles in other countries? Circles have appeared in countries including Italy, Germany, the Netherlands, Argentina, Belgium and even the Czech Republic.

Were they the work of other pranksters emulating the Englishmen, or could they be ancient symbols or alien signs? In 2002, M. Night Shyalaman's movie *Signs* concluded crop circles were a series of alien maps that led to an alien invasion. The film was shot in Pennsylvania, and real crop circles were created rather than generating them on a computer.

Study of the phenomenon continues among paranormal enthusiasts and UFO researchers, but their theories are often dismissed by skeptics.

THE BIBLE THAT WOULDN'T LEAVE THE CHURCH

Tucked among rolling, picturesque hills in middle Tennessee is a simple white church surrounded by a bramble-filled hollow, kudzu-covered trees and the graves of its former

congregants. Goshen United Methodist Church near Santa Fe is one of the oldest congregations in the state. As with any historical building, Goshen has generated a legend— one of a ghostly presence that believes in the Bible.

Founded in 1808 by John Fly, Goshen was initially what is known as a "brush arbor church" or "church in the wildwood." Members would meet outdoors for worship for the next twenty-seven years. In 1835, a log structure was built, including an open fireplace. The present clapboard building was constructed in 1882. It was a one-room church reached by a winding chert road that wasn't paved until more than 150 years later.

In 1949, when Goshen had an average Sunday school attendance of twenty-three souls, the building was renovated and wired for electricity. Three Sunday school rooms were added to the building in 1965, and the church's original hand-hewn poplar benches were replaced by modern ones three years later. Indoor plumbing was added in 1979.

The still-cozy church now boasts a fellowship hall and a kitchen, as well as five classrooms in the basement. The oldest burial in the adjoining cemetery is that of the Reverend John Crane, who died at the age of twenty-six in 1813, mere months after he was named the circuit-riding preacher for the towns of Santa Fe, Franklin, Columbia and Goshen. It apparently was his dedication that killed him, as he rode from town to town, despite cold or rain, and succumbed to an inflammation of the lungs. His

gravesite, just steps outside the church door, is a United Methodist Historic Site.

These days, the church has ninety-two members and continues to grow. In 2008, congregants celebrated the 200th anniversary of the founding of the church with special programs and plays.

The Bible-believing ghost legend has been passed down for many of those years. According to lore, the large Bible on the church pulpit could not be taken outside the building after dark. Anyone who tried would be unable to step across the threshold to take it away.

Church historian Jewell Baker Shouse said the origins of the legend are unclear. "No one seems to know how or when this story originated but it has been attempted for generations by teenaged boys and others who were dared to do so by friends," Shouse wrote in a church history.

Some were successful in stepping outside the door, she wrote, but they would quickly return the Bible to the pulpit. "It is told that one fellow took it home with him one night but couldn't get up the nerve to return it till the next day during daylight hours," Shouse wrote.

In those days, the tiny isolated church was rarely locked. There seemed to be no need. The well-worn, beloved Bible disappeared from the pulpit for good in 1975.

THE HAUNTED
MANSIONS OF FRANKLIN

On the morning of November 30, 1864, Johann and Margaretha Lotz (pronounced *Loats*) received the news that Union and Confederate soldiers were readying for a massive clash. This news wouldn't have been so unusual, except that the battle was expected to occur in the Lotzes' front yard. Johann Lotz, a German immigrant and master carpenter, completed his beautiful wood-plank home in Franklin, Tennessee, in 1858 to show potential customers his extensive carpentry skills. The curved stair railing that wraps from the first floor to the second was made from a single piece of black walnut. The home also features three fireplace mantels of varying styles to showcase Johann's exceptional talents.

But six years later, on November 30, Johann's thoughts were for his family's safety, and he knew his wooden home wasn't as sturdy as the Carter family's brick home, located 110 steps across Columbia Avenue. The Carter mansion had a brick basement, and its owner, Fountain Branch Carter, invited the Lotzes to bring their six-year-old daughter, Matilda, and two sons, Paul and Augustus, to hide in their home.

The families would take cover for seventeen hours as the Battle of Franklin raged—a clash that historians would call the most severe hand-to-hand combat of the Civil War. When the families emerged, bodies of dead soldiers

lay thick on the ground between the homes and all around them. More than 8,500 soldiers from both sides had been killed, and many more were wounded.

The sight was devastating to Johann, Margaretha and the children. The Lotz home was used as a hospital, but Johann could no longer stay after what the family had witnessed. He soon would move his family away.

In 2008, the current owners turned the beautifully restored home into a Civil War museum. But according to the Travel Channel show *Most Terrifying Places in America*, something still lives inside the Lotz house—something unearthly. The show that aired in October 2010 told of the deaths that occurred on the property and the energy that remains. According to those who run a ghost tour, called Franklin on Foot, the Lotz House Museum is haunted by a woman wearing a nightgown, who cries out for a loved one and a little girl, who can be seen staring out a window. Could it be that little Matilda Lotz, perhaps, is still haunted by the sight of thousands of dead soldiers?

People also have reported seeing objects move and hearing the sounds of women's voices when no one is inside the home. Evidence of the battle still can be found inside the home. A hole in the second floor was patched after a cannon ball flew through the roof, crashed through the floor and slammed into the first floor, leaving an indentation and a blackened mark where the hot ball rolled to a stop.

One soldier, Sam Watkins of the First Tennessee Infantry, would later write in his journal that the Battle of Franklin "is the blackest page in the history of the War of the Lost Cause. It was the bloodiest battle of modern times in any war. It was the finishing stroke to the Independence of the Southern Confederacy. I was there. I saw it."

Across the street from the Lotz home, the modest brick Carter home still stands. Built in 1830 by Fountain Branch Carter, it, too, is said to be haunted. Carter was a sixty-seven-year-old widower when the battle began. He had seen three of his sons—Tod, Francis and Moscow—fight for the Confederacy. Moscow Carter, paroled as a prisoner of war, took refuge in the basement along with his father, the servants, the Lotz family and other neighbors.

Theodrick Carter, called Tod, was a captain serving as an aid for General T.B. Smith. When he saw his home for the first time since the war began, it was at the start of the bloodiest battle he would witness. By the end of it, Tod would be mortally wounded. When the fighting stopped, Moscow and General Smith searched until they found Tod, lying on the battlefield—only about one hundred yards from home. They returned him to the house, where he died two days later on December 2, 1864. He was buried the same day in Rest Haven Cemetery just north of Franklin.

The Carter home, too, served as a hospital. The Carter House opened as a museum in 1953, eight years before it would become a Registered National Historic Landmark.

Visitors to the home claim that "pranks" have been played by unseen entities and objects disappear and reappear. Some claim to have seen the ghost of Tod Carter sitting on the edge of the bed in the room where he died. As with the Lotz house, some claim to have seen the apparition of a little girl, moving along the upstairs hallway and down the stairs and to have heard a friendly female voice.

The unusual occurrences are not surprising in a home still scarred from battle—more than one thousand bullet holes can still be seen in the main house and surrounding buildings.

A third home impacted by the battle was the Carnton Plantation, located about a mile from the Lotz and Carter homes. Carnton was built in 1826 by former Nashville mayor Randal McGavock, who was living in the home with his wife, Carrie Elizabeth McGavock, and two children, Winder and Hattie, when the battle occurred.

When the fighting ended, many of the dead and dying were laid out in the mansion, including the bodies of four Confederate generals who were temporarily placed on the Carnton porch—Patrick R. Cleburne, Hiram B. Granbury, John Adams and Otho F. Strahl. Visitors to the plantation home will see the floors still stained with blood from the dead and dying.

Today, it is a museum and a beautiful location used for weddings and events. But it, too, is said to be haunted with the spirits of those killed in the Battle of Franklin.

THE GIRL IN SEAT C-5

The majestic Orpheum Theatre in Memphis is today—as it has been for more than eighty years—a place to take in a show in unparalleled surroundings. And one little Memphis girl returns again and again to see her favorite performances. The little girl named Mary always wears a white dress and pigtails, and she prefers seat C-5 in Box 5. Mary sits quietly, enthralled by the shows, according to the Orpheum's official history.

Dozens of performers and theater employees have seen little Mary. The first thing they notice is that she is no longer among the living. The apparition is said to be the spirit of a child who reportedly died in the early 1900s after being struck by a trolley in a nearby street. According to one legend, the injured child either wandered into or was carried into the theater, where she died. However, Dr. Lee Sutter, a parapsychology professor at the University of Memphis, discovered the little girl never entered the theater.

That doesn't stop reports of the apparition, which is now embraced by Orpheum officials. Because of the sightings, the Orpheum was featured on the Travel Channel television show *Most Terrifying Places in America* in October 2010.

The lush Orpheum Theatre came into being on the site of the Grand Opera House at the corner of Main and Beale Streets. The opera house, built in 1890, began showing Orpheum Circuit vaudeville shows in 1907 and

became known as the Orpheum. The opera house burned in 1923, just as a striptease artist named Blossom Seeley was performing.

A new Orpheum Theatre was built on the site in 1928, bigger and better than its predecessor, featuring red velvet seats, crystal chandeliers and gilded moldings. It also is home to a Mighty Wurlitzer pipe organ. From 1940 to 1976, the Orpheum was used as a movie theater.

There was talk of demolishing the aging theater when, in 1977, the Memphis Development Foundation saved it. After a restoration, the theater now hosts Broadway shows, concerts and a variety of performers.

THE PHANTOM MONK

In March 1867, one of the worst floods to hit the South covered much of Tennessee in water. The *Knoxville Commercial* reported: "We are now in the midst of a terrible flood. The waters are upon us and still continue to come… The rain continues to fall and is falling in torrents and the river rapidly rising. It is gloomy indeed." In the small town of Charleston, the waters left the banks of the Hiwassee River and ravaged the city.

As a passenger train entered town, the engineer was unaware of the severity of the flood. He could not see that the railroad tracks that connected the town to the world had washed away. The train, now derailed, slid into a

ravine. Many people would die that day; it was a tragedy that led to one of Tennessee's enduring legends, the tale of the Phantom Monk.

Rescuers got to the horrific scene quickly and began pulling bodies from the mud and wreckage. Those who were not dead were taken to nearby homes because there was no hospital in the town, only a small clinic run by the local doctor.

Finally, after hours of grueling work, the rescue team was finished. All the survivors and the bodies had been recovered. Or had they?

Town officials soon would discover one of the passengers on the train was unaccounted for. His name was unknown. People remembered only that he was a Catholic monk from Baltimore. People thought it odd that all bodies but this one would be found. It was a mystery.

They wouldn't learn until many years later that the monk's body *had* been found. According to legend, the body was recovered by a local physician who, for reasons unknown, decided to keep it. He removed the flesh and cleaned the bones and hung the skeleton in his office.

The monk's spirit could not rest, the legend says. It haunted the clinic for many years until the doctor's death. The next doctor to take over the practice reported that he, too, had many encounters with the restless spirit.

The old clinic was finally demolished in 1932. Local lore says the crew responsible for tearing down the building found the monk's cloak and a rosary between the walls.

Despite the absence of the building, local residents still report seeing the apparition of a young monk, walking along the railroad tracks at night, searching for peace.

THE CURSE OF THE TENNESSEE RIVER SERPENT

Since the seventeenth century, people have reported sightings of a huge sea serpent in the Tennessee River. But the serpent is not like the creature that allegedly inhabits the Loch Ness in Scotland: Legend says the Tennessee serpent carries a curse. It was in the spring of 1922 that Buck Sutton was fishing in Van's Hole along the river when he noticed the dark waters moving.

Suddenly, he saw what he described as a "monstrous" fish thrashing thirty feet from the bank, according to a story on the history of the legend in the *Spartanburg Herald-Journal* in 1993. "It was the creature," he reportedly said. "I could see the thing clear as day."

Sutton had heard the legends that sighting the serpent "meant certain doom," the article stated. Within days, Sutton was dead. The creature, which had been spotted in the area for decades, was described as being about twenty-five feet long, having a huge head shaped like a dog's and having a black fin on its back.

Just five years after Sutton's sighting, Billy Burns was in a canoe near the same spot where Sutton saw the serpent.

The canoe capsized, and Burns noticed a creature as long as his boat. By the next summer, Burns, too, was dead. In 1829, according to legend, a farmer named Jim Windom saw a strange creature while fishing near Van's Hole.

Having heard of the curse, a terrified Windom began attending church regularly. But he, too, would soon die, succumbing to a mysterious fever. Sightings continued in the 1830s, but the curse seems to have waned.

Sallie Wilson and her husband, J.C., saw the creature on separate occasions with no ill effects, according to the *Herald-Journal*. Wilson described the creature as "playful." On March 13, 1888, the *New York Times* published a story headlined: "The Sea Serpent in the Tennessee."

The story, datelined Knoxville, March 9, stated:

> *A fishing party of four men report a novel and dangerous experience in the Tennessee River, a few miles below this place. This afternoon, while crossing in a yawl, a serpent-like fish, fully 10 feet in length, capsized the boat and threw all the men in the water. The boat was lashed to pieces and the men barely escaped with their lives.*

No sightings have ever been verified by scientists but the legend of the Tennessee River Sea Serpent lives on.

THE VOODOO HEX MURDER

In March 1957, a man who made a career of forecasting murders and deaths was himself the victim of a shocking crime in Shelbyville, Tennessee. Sixty-year-old Simon Warner, who called himself a "crime doctor" and prided himself on "keeping down murders," wasn't able to foresee his own murder.

He was shot five times with a .32-caliber pistol.

The reason for the murder was as shocking as the death of the "crime doctor." Within three hours of the slaying, Alabama police arrested Mose H. Martin in Stevenson and charged him with first-degree murder. Forty-year-old Martin claimed Warner put a voodoo hex on him.

According to the March 24 edition of the *Gadsden Times* in Alabama, Martin told authorities: "I shot him because he double-crossed me in voodoo. I would have shot anybody who double-crossed me in black magic like he did."

Patrolman Durwood Thompson said Martin told him he had paid Warner sixty dollars to cure a stomach ailment, but instead Warner had hexed him and his condition worsened, according to the *Kentucky New Era*'s March 23, 1957 edition. Warner had said he might "see" a murder months in advance, and "I always do all I can to keep it from happening."

THE LADY WHO
DANCED HERSELF TO DEATH

It was a golden time. The land had been settled, some early pioneers had grown rich and the upper class had time and money on their hands. In Harrodsburg, Kentucky, one pioneer, Dr. Christopher Columbus Graham (1784–1885) capitalized on the area's natural resources. He purchased two natural springs in the 1820s—Greenville and Harrodsburg Springs—and created a spa known as Graham Springs, which became one of the era's greatest attractions.

In 1842, he used proceeds from the attraction to build Graham Springs Hotel. At a cost of $30,000, the four-story building was known as one of the most magnificent in the state. The resort became the vacation spot of choice for wealthy plantation owners from farther south. Guests could enjoy the "healing" waters for $20 per month, as well as lively entertainment during the height of the social season from June to September.

Not long after the hotel opened, a beautiful woman in her twenties came to the hotel with a man. She registered as Virginia Stafford, daughter of a Louisville judge. One night, as on most nights, there was a party in the ballroom. The young woman danced with her partner, and then with many of the other men present. She is remembered as being vivacious and dancing nonstop with a strange passion.

But then, an event occurred that would stop the music. The woman's partner realized she had died in his arms.

Shocked, the hotel staff tried to reach the judge, only to learn he had no daughter named Virginia. The woman's partner said he only knew her as Virginia Stafford, which obviously was not her true identity. Not knowing what else to do, hotel staff and guests held a funeral for the woman. She was buried in front of the hotel.

Townspeople began referring to it as the grave of the Lady Who Danced Herself to Death. Around 1920, the hotel burned, and the land where the mysterious woman was buried became a city park. Her grave was left undisturbed.

After the fire, people claimed to see the figure of a woman dancing around the gravesite on moonlit nights. The figure in white would twirl to music no one else could hear. Had the Lady Who Danced Herself to Death been disturbed? Was she begging someone to uncover her identity?

For about seventy-five years, the woman's identity was unknown. In the 1920s, a man known only as Mr. Rupp of Tennessee was told about the legend by a Mr. Adams. Rupp responded by saying, "I know who that woman is."

Rupp said that, when he was ten years old, Joe Sewell of Tazewell, Tennessee, told him that his second wife had danced herself to death at the Graham Springs Hotel. Her name was Mollie Black Sewell. The pair had apparently been estranged, as Joe Sewell had a wanderlust of which his wife grew tired.

According to Rupp, the couple had a young son. If this version of the story were true, why had Sewell never claimed his wife's remains? What happened to their son? The mystery remains.

The Lady Who Danced Herself to Death still lies beneath a grave in Kentucky surrounded by a white picket fence that bears a sign that reads:

> *Unknown*
> *Hallowed and*
> *Hushed be the*
> *place of the dead.*
> *Step Softly.*
> *Bow Head.*

Chapter 6

CURIOUS CREATURES

IN MEMORY OF DAMMIT THE DOG

On the campus of Tennessee Technological University in Cookeville is a memorial to a stray dog that once roamed among students. A small stone set flat into the earth next to a red fire hydrant is inscribed "In Memory of Dammit, 1954."

Tennessee Tech archivist Mancil Johnson said more myths surround Dammit than any other campus legend. Tennessee Tech, located seventy miles east of Nashville, has a long and respected history. It was formerly known as Tennessee Polytechnic Institute, and before that as Dixie College, the name under which it was founded as a private institution in 1909.

Dammit arrived about 1954. He was an Australian blue heeler that students spotted in the road at a basketball

game in Kentucky. One of the students yelled, "Get out of the road, dammit. Do you want to get run over?" The dog approached the students, so they took him home to Cookeville, where he would slip inside dorms to sleep and get scraps of food, sneak into assemblies only to steal the applause meant for the speaker and chase cars, but only those with white-wall tires.

The legends perpetuated on the Internet bestow the honor of naming Dammit on more famous men. Some say Gordon Browning, governor of Tennessee from 1937 to 1939 and again from 1949 to 1953, was on campus when the dog blocked his path. He reportedly said, "Dammit, get out of here." To excuse his bad language, he added, "That's the dog's name, isn't it?" Another legend states it was university president Dr. Everett Derryberry who spoke these words.

Yet another tale has to do with Dammit's burial: after a funeral that included a small casket, a student procession carried it to the gravesite. But Dammit is not buried beneath this grassy spot by Derryberry Hall, because no one is sure what became of this favorite campus pet.

Today, students sometimes leave flowers beside Dammit's memorial. His legend likely will continue to grow. The university has many other legends, including the reason the T.J. Farr Building is one of the few buildings on campus not called "Hall." When someone from the South says "Farr Hall," people think they are referring to something other than an academic building: a fire hall.

THE TALE OF THE BULGY-EYED FAINTING GOATS

In the early 1800s, a stranger in odd dress appeared in Marshall County, Tennessee. Odder still were the four goats he had with him, three does and a buck. The goats had prominent, bulging eyes, and when startled, they fell over in a stiff-legged faint. The stranger farmed for a while but would leave town within a year or so. Before leaving, he sold the strange goats to Dr. H.H. Mayberry, who recognized their uniqueness. Mayberry reportedly paid thirty-six dollars for the four goats.

The goat man, whose name was John Tinsley, was thought to be from Nova Scotia, but Mayberry was unable to find a record of such unusual goats anywhere else in the world. He began to breed them, and soon, Marshall County was famous for its bulgy-eyed fainting goats. To celebrate that fact, the town of Lewisburg in Marshall County holds a fainting goat festival each October. But apparently the name Fainting Goat Festival was not much of a tourist draw, so it was changed recently to Goats, Music and More. Lewisburg's mayor may be the only official in the world who gets to present a ribbon to the Grand Champion Fainting Goat.

Competitions are held to find the best fainting and Boer goats, and visitors can listen to a variety of musical entertainment, shop at the crafts show and sample food from vendors. According to festival officials, fainting goats

were almost extinct by the 1980s, because farmers were letting them run in herds with other breeds, and the fainting trait became diluted. The breed made a comeback when people began raising them for their unique appeal.

The earliest written record of the goats was in 1904 when they were described by George R. White, state veterinarian of Tennessee, and Joseph Plaskett. White had bought a

pair from a farm in Maury County and was interested in studying them. These days, a number of farmers across the south breed fainting goats. They are a gentle breed and easy to raise, particularly since their unusual "fainting" trait prevents them from jumping fences. The trait is called "myotonia," which causes the goat to stiffen and fall over when startled or surprised. It does not hurt the goats, which recover quickly.

For more information on the Goats, Music and More Festival, contact the city of Lewisburg at 931-359-1544.

TENNESSEE'S LOVE AFFAIR WITH HORSES

A 1904 advertisement invited the public to see Beautiful Jim Key at the World's Fair in St. Louis. Price of admission was fifteen cents, a fair amount considering visitors would get to see a horse who, according to the ad, "Reads, Writes, Spells, Counts, Figures, Changes Money Using a National Cash Register, Even Gives Bible Quotations."

Jim Key was a stallion foaled in Shelbyville in 1889. He was owned by a former slave known as "Dr." William Key, a self-trained veterinarian. The horse was purported to have the IQ of a human sixth grader and could tell time, sort mail, use a telephone and more. He and his owner became renowned in 1897 and performed across the country.

Jim Key was billed as the "smartest horse in the world" and was valued at $1 million. He spelled his name using alphabet blocks and solved math problems using numbered blocks. In October 4, 1897, the *Pittsburgh Press* published an article on the horse's performance:

> *"Beautiful Jim Key," the educated horse, has captured the hearts of all who have seen him at the Pittsburg exposition…One of his most remarkable tricks is to get a silver dollar from the cash register, which he opens with his teeth, drop the dollar into a glass jar filled with six gallons of water, and then at the request of this trainer he picks the dollar out without drinking a single drop of water…Jim is giving exhibitions every day this week and no one should fail to see him, for he is a wonder in every sense of the term.*

"Dr." Key was born a slave in 1833 in Murfreesboro, Tennessee, and moved to Shelbyville at the age of five. He was known early on for his "horse whispering" capabilities. He would later follow his master's sons to the Civil War to protect them. After the war, Doc opened a hospital for horses in Shelbyville. He formed a special bond with Beautiful Jim Key when the foal's dam died, and the foal refused to leave Doc's side. Doc fed the horse by hand.

He trained Jim Key and, after several years of touring, Doc was one of the most recognized African Americans of

his time. He would insist on giving special performances for black audiences at a discount, and he convinced planners of the World's Fair in Charleston, South Carolina, to have a day exclusively for black audiences.

Jim Key had a huge impact on popular culture at the time. As many as two million children joined the Jim Key Band of Mercy and signed the accompanying pledge: "I promise always to be kind to animals and other sentient beings."

Key died in 1909, three years before his beloved horse. He is buried in Willow Mount Cemetery. The remains of the horse were moved from Key's property in 1967 to a field three miles south of the Shelbyville courthouse on Highway 130.

In Tennessee, a state known for its horses, the gravesites of two other famous equines are tourist attractions:

- **Old Isham.** In Beech Grove, off U.S. Highway 41, is a lonely grave, once forgotten, that bears the remains of Old Isham, known as the Rebel war horse. Isham was the horse of Confederate general Benjamin Franklin Cheatham. The horse was named for Isham Harris, Confederate governor of Tennessee. Old Isham's date of death is unknown, but it was after war's end and before Cheatham's death in 1886. Cheatham buried Isham on his property with full military honors.

 The grave was left unattended for decades but was rediscovered in the early 2000s. In 2002, a unit of the Sons of Confederate Veterans

placed a tombstone on the grave, built a wooden fence around it and installed a Confederate flag. The horse's marker is inscribed: "Old Isham, CSA, Honored Mount of Gen. Cheatham."

To reach the grave, take exit 105 off Interstate 24, go north on U.S. 41, and go down a large hill. Past a sign for Noah Fork, turn left on French Brantley Road. Drive for about a mile and the grave will be on the right.

- **Strolling Jim.** Near the stables of the Walking Horse Hotel in Wartrace is a granite monument to a horse that defined a breed. Strolling Jim was the first world champion Tennessee walking horse, a show breed.

Strolling Jim was a chestnut gelding foaled in 1936 near Viola. Within his first two years, he was sold to Charlie Ramsey, who used the horse to pull a plow and other implements on his farm. When Ramsey rode the horse, he noticed Strolling Jim walked with speed and comfort to his rider, according to the website walkerswest.com. Horse dealer Henry Davis heard of the horse and took top trainer Floyd Carothers to see Strolling Jim. The pair bought the horse that day, April 30, 1939.

Carothers worked daily with the horse, and people began to come to the barn to see the pair in action. The horse would be sold again to Colonel C.H. Bacon of Loudon; Carothers

remained his trainer. Strolling Jim won twelve straight walking horse sweepstakes, even before winning the first Tennessee Walking Horse National Celebration in 1939. The next year, he again won twelve straight stakes and also was crowned grand champion at the Tennessee State Fair Show in Nashville. He would continue to win shows and astound audiences throughout his life.

Strolling Jim died at age twenty-one on April 23, 1957, in Wartrace and was buried near the hotel stables. The restaurant at the hotel is named Strolling Jim Restaurant, which houses what the owner claims is the world's largest collection of Tennessee walking horse photos and art. Visitors can watch films of Strolling Jim on video monitors and purchase Strolling Jim hats and T-shirts in the gift shop.

The hotel is located at 101 Spring Street in Wartrace.

A Firefly Mating Ritual

In the Great Smoky Mountains in Elkmont, Tennessee, one of nature's most spectacular light shows takes place each summer. It is one of two places in the world—the other is in southeast Asia—where thousands of fireflies light in unison for two weeks each June.

The fireflies of this species, the *Photinus carolinus*, have internal sensors that alert them when they are near another firefly, which causes the fireflies to light. Tennessee is home to fourteen species of fireflies, which in the south also are known as lightning bugs. The firefly is one of three state insects, including the ladybug and honey bee.

Synchronous fireflies are the only species in the country that have the ability to flash in unison. Researchers are not sure why but believe it could have to do with mating. The peak season to view the synchronized flashing is mid-June. If you go, remember the synchronicity is not guaranteed. The insects may flash in waves or randomly.

According to the website for Great Smoky Mountains National Park, people should observe guidelines to best enjoy the light show. Viewers are asked not to catch and trap the insects. Flashlights impair people's night vision and can disrupt the fireflies.

The fireflies gather at the Little River Trailhead at Elkmont, near Gatlinburg, in Smoky Mountains National Park. For park visitor information, call 865-436-1200

For the Love of Mules

George Washington may be known as the Father of our Country but he also is the Father of Mules in our Country. While Columbia, Tennessee, calls itself the Mule Capital of the World, credit for introducing mules in the United States goes to old George. Before he became president, General Washington was interested in bringing mules—the offspring of a male donkey and a female horse—to his farm after he heard of their many attributes: they are strong like horses but eat less, work longer and have gentle dispositions. Washington reportedly contacted the U.S. ambassador in

Spain, where mules were bred. In response, King Charles III of Spain sent Washington the gift of a male donkey in 1785, which Washington bred for mules.

Mules were popular farm animals in the south before the advent of tractors. In Maury County, Tennessee, farmers and breeders would come together one day each spring to show, buy and trade the animals. Known as Breeders' Day, the tradition began in the 1840s.

Eventually, the trade day morphed into a four-day festival known as Mule Day. Events include a Mule Day parade, led in 2010 by Naomi Judd; mule competitions; lumberjack contests; music; dancing; and a crafts show. A Mule Day queen is crowned during the event. Buying, selling and trading also occur at Mule Day.

Held in late March and early April, the event now attracts as many as 200,000 people. While Columbia's is the largest and oldest such event, other towns host Mule Day events, including Benson, North Carolina, begun 1950; Bishop, California, begun 1969; Calvary, Georgia, begun 1973; Winfield, Alabama, begun 1975; and Ider, Alabama, begun 1987.

For more information on Columbia's Mule Day event, call 931-381-9557. Tennessee has connections to several famous mules:

- **Amazing Grace.** This five-year-old mule, bred from a quarter horse mare, was one of the main attractions at Columbia's 2010 Mule Day. Trained by Steve Foster of Virginia, Amazing Grace can

perform dozens of tricks—including painting and shooting hoops—and is a decorated show mule. In 2008, it won the national competition "America's Ultimate Horse Idol" in Richmond, Virginia. It has appeared on several television shows and was filmed to appear on the History Channel Show *Only in America with Larry the Cable Guy*. But the mule's biggest accomplishment to date is starring opposite Robert Duvall, Sissy Spacek and Bill Murray in another Tennessee tale, the film *Get Low*, about famed Tennessee hermit Felix Breazeale.

- **Allen Bluff Mule.** Near Liberty, Tennessee, drivers along Highway 70 see a strange sight on a cliff overlooking the road: a painting of a mule. Several stories circulate as to the origin of the painting known as the *Allen Bluff Mule*. Liberty residents have become attached to the mule and, in 2003, voiced opposition to a highway expansion that threatened the painting. Save the Mule signs dotted the highway, and the Tennessee Department of Transportation was flooded with letters. Turns out, the expansion did not come close to the mule.

The origin of the painting still is uncertain, but a March 1957 article in the *Smithville Review* quotes Dr. Wayne T. Robinson:

> *In early October 1906, I climbed up the face of the Allen Bluff to a ledge and with some coal tar*

made a flat picture of a character from a famous comic strip of that day. Everybody remembers Maud, the mule. That was 51 years ago, and even though it has been exposed to the elements and to nearby earth-shaking explosions, erosion has dimmed it very little.

- **Black Jack.** Since 1899, a mule has been the mascot of the United States Military Academy (Army) sports teams. That was the year students decided they needed a mascot for the game against chief rival Navy, which had a goat mascot. A mule was chosen because the animals were strong and provided many useful services in military operations. Since that first mule, which for its "day job" pulled an ice wagon, dozens of mules have become mascots for the proud organization. On October 25, 1985, then Tennessee senator Albert Gore Jr., who would go on to become vice president of the United States, presented a mule named Black Jack to the Corps of Cadets. Gore's gift was in conjunction with the Lynchburg Mule Show and Letting at Lynchburg, Tennessee. The jet-black mule weighed one thousand pounds and was bred from a Tennessee walking horse and foaled in Gatlinburg in 1978. Black Jack died of cancer on December 7, 1989, two days before the Army-Navy football game.

- **Stolen mule.** During the Civil War, as many as six thousand music titles were published in the south, according to the Tennessee Library and Archives. One such song capitalized on a favorite slogan of the time: "Where's your mule?" or "Here's your mule."

 Written by C.D. Benson and published in Nashville, the song "Here's Your Mule" had humorous lyrics and was often sung in soldier camps. The initial slogan is said to stem from an incident when soldiers hid a mule from a peddler, and when he came into camp looking for it, one would holler, "Here's your mule." But when the peddler came close, another soldier would call out: "Mister, here's your mule."

THESE DUCKS MARCH TO THEIR OWN BEAT

Was it a drunken prank that led to a group of mallards living in a $200,000 Memphis penthouse complete with swimming pool and ceiling fans? According to the official history of the Peabody Hotel, that sums up the story of the Peabody Ducks, which rank among the state's most famous animals.

For more than three-quarters of a century, the ducks and their daily marches have been fixtures at the historic hotel. When two new Peabody Hotels were built in

1986—one in Orlando and one in Little Rock—the tradition was begun in those locations, as well. And it all began with two hunters who, in 1933, were sipping some Jack Daniel's whiskey when they had the idea to put their live decoys in the fountain in the hotel lobby. The men, hotel General Manager Frank Schutt and his friend Chip Barwick, placed three English call ducks in the fountain, and guests loved the playful ducks. Before long, five North American mallard ducks were brought in to make the one-time prank into a tradition.

But the creativity didn't end there. Seven years later, a bellman, who had worked as a circus animal trainer, asked if he could help bring the ducks down to the lobby each day from their rooftop pen. Edward Pembroke soon taught the ducks to march and was named the Peabody Duck Master, which is now a trademarked term, and one very few people can lay claim to. Pembroke acted as Duck Master until he retired in 1991.

Since the march was introduced, the ducks are escorted by elevator daily at 11:00 a.m. to the fountain. Guests and tourists gather as the ducks, accompanied by Sousa's "King Cotton March," cross a red carpet to the marble fountain. During the day, the ducks swim and frolic in the fountain's water, before retuning upstairs for dinner and bed at 5:00 p.m.

Once housed in a fancy cage, the ducks got lavish new digs in 2008, according to the *Commercial Appeal* in Memphis. Their penthouse has granite floors, ceiling fans,

a swimming pool, a fountain decorated with bronze duck statues and a miniature version of the hotel as their roost. It isn't as if they don't deserve to be coddled. The ducks have earned their celebrity, appearing on the *Oprah Winfrey Show*, *The Tonight Show with Johnny Carson* and *Sesame Street*. Celebrities also have enjoyed the title Honorary Duck Master, including Oprah Winfrey, Kevin Bacon, Queen Noor of Jordan and Patrick Swayze.

In 1988, hotel officials decided people outside the south should meet the ducks. The five mallards were taken on a world tour. For more information on the Peabody Hotel or the duck march, call 901-529-4000.

TAKING UP SERPENTS

The year 1955 was a busy one for the faithful who believe in the practice of "taking up serpents." That was the year a man known as the group's founder was killed by a snakebite. Snake-handling religions, which many describe as cults, became active in the Appalachian Mountain regions of Tennessee, Alabama, North Carolina, Kentucky and Virginia. Many residents in these communities think any publicity of snake handlers gives a negative stereotype about mountain people.

The practice of snake handling during religious ceremonies was begun in 1909 by George Went Hensley of Grasshopper, Tennessee, a Church of God pastor who

preached that the Bible should be taken literally, including the verse Mark 16:17–18: "And these signs shall follow them that believe; In my name shall they cast out devils; they shall speak with new tongues; they shall take up serpents; and if they drink any deadly thing, it shall not hurt them; they shall lay hands on the sick, and they shall recover."

When the Church of God later banned the practice, Hensley formed his own church and continued handling snakes. He and his followers believed that if they were bitten and died, it was God's will. Any bites remained untreated, so if the bitten person survived, that, too, was God's will.

By the 1940s, following a number of snake bite deaths, states began to outlaw the practice of serpent handling. Only West Virginia allows the practice legally. While numbers are difficult to track, experts believe as many as one hundred people have died handling snakes.

In July 1955, George Hensley was bitten by a diamondback rattlesnake and killed during a service in Florida. He was seventy. While it may seem that would shake his followers' faith, it seemed to have an opposite impact: his widow, Sally, vowed to continue her husband's mission and the church continued.

Snake handling is still practiced today in tiny churches tucked away in mountain communities, but experts believe fewer than two thousand believers remain across the United States.

OLD LIMBER:
ALF'S LEGENDARY FOXHOUND

In 1921, Alfred "Alf" Taylor, governor of Tennessee, got stern with the state legislature and threatened to veto a proposed measure. The story was published in newspapers across the state. What proposal caused such consternation? It was an appropriation for a "state doghouse" on the grounds of the Nashville capitol for the governor's prized foxhound.

Whether Taylor, known for his exaggerations, was behind the plan or whether he was ignorant of it, once the press got wind of it, he immediately stated he would veto funds for a house for Old Limber. After all, he said, Old Limber was a country dog that would not be happy in the city. Taylor made use of his dog on the campaign trail, citing his hunting prowess in many speeches. A report in the *Woodville Republican* in Missouri on March 5, 1921, stated: "Old Limber, the only dog whose yelp was ever heard in a political campaign in Tennessee, has not been tempted from his familiar haunts in Happy Valley vicinity by the bright lights of the capital [*sic*]."

At the time, Old Limber was reportedly nine years old, and Taylor argued the dog would prefer to live at Taylor's Happy Valley home where he could "occasionally survey the mountains." The article quoted Taylor: "That dog never lied to me in his life. He has never been known to yelp on a cold trail. Whenever the voice of Old Limber is heard, everybody knows that there is a fox around."

In 1922, Old Limber was mentioned in the *New York Times* when it published an article on the opening of the Tennessee Fox Hunters Association Dog Derby. Six years later, on April 13, 1928, newspapers across the country, including the *New York Times*, published a story of a huge foxhunt at which Alf, the eighty-two-year-old retired governor, was a central figure. The following day, a massive banquet was held in Taylor's honor, and he insisted Old Limber, who would have been seventeen years old based on Taylor's previous accounts, share the honors with him. After all, Taylor told reporters Old Limber had managed to lead the pack of more than one hundred hounds during the hunt.

How much of Taylor's stories about Old Limber were true is open to debate, but his love for his companion was never questioned. Taylor and his brother, Robert, already had earned plenty of press long before the days of Old Limber. Alf and Bob were the brothers who ran for governor against each other in what became known as the "War of the Roses: Campaign of 1886." The two men reportedly kept their humor about the race, even when Bob, as a practical joke, recited a speech written by his brother at a campaign stop. Bob would win in 1886, but Alf would run again in 1920 and win.

Alf died of pneumonia at age eighty-three in 1929.

Old Limber died on November 2, 1923. His true age at the time, according to Brennan LeQuire with the Blount County Library, was nine. Before his death, Old Limber's pawprints were embedded in concrete on a walkway in front of Taylor's home in Milligan.

Best Friends: Tarra and Bella

On a trip through the beautiful rolling hills and pastures of Tennessee, most people know they are likely to see horses, cattle and perhaps a country music legend or two. But the sight of aging, retired elephants roaming happily may come as a surprise to visitors. And, not wanting to surprise the elephants with gawking visitors, the founders of the Elephant Sanctuary at Hohenwold placed it off the beaten path on 2,700 acres.

It is not open to tourists because its purpose is to provide a safe haven as much like the elephants' natural habitats, away from the stares and noises many endured for years as circus performers or in zoos. The sanctuary has separate habitats for Asian elephants and African elephants, as well as a quarantine area. Opened in 1995, it currently houses thirteen Asian and two African elephants with a goal of one day providing refuge for as many as one hundred sick or aging elephants.

The elephant that led to the creation of the sanctuary—Tarra, a circus elephant who needed a place to retire—is also the subject of one of the most popular and heartwarming stories to come from the sanctuary. Tarra, born in Burma in 1974, was sent to the United States not long before Asian elephants were placed on the endangered species list and importations were halted. Tarra would connect with exotic animal student Carol Buckley and would spend twenty years entertaining

audiences in a circus, at amusement parks and zoos and on television and in movies.

Tarra also was an artist, painting by holding brushes with her trunk. Her artworks have been exhibited around the country. When it was time for Tarra to retire, Carol Buckley and Scott Blais founded the sanctuary. After retiring to the newly opened sanctuary in 1995, the 8,700-pound Tarra roamed with her new "herd." But elephants, like people, form emotional bonds, and it wouldn't be until the arrival of a stray dog that Tarra would find her best friend.

Tarra and the dog, Bella, bonded after Bella was found abandoned on newly acquired sanctuary land. Although most of the dogs on the property shied away from the elephants, Bella seemed to love Tarra's attention. The odd pair spent many hours together—roaming, eating, sleeping and playing.

But it was when Bella suffered an injury that the strength of the bond became evident. After a spinal injury in 2007, the dog had to remain motionless, unable even to wag her tail, in the barn. Nearly two weeks into the recovery, Tarra came and stood under the barn window. Bella's caregiver held the dog up to the window so Tarra could see her.

Bella wagged her tail. This would be repeated each day until Bella was able to rejoin Tarra in the sanctuary. Then Steve Hartman did a report on the pair of friends, which aired on the *CBS Evening News with Katie Couric* in January 2009. The story was posted on cbs.com, then on YouTube and, before long, it went viral. Offers came pouring into

the sanctuary for books and a movie about the pair. But the sanctuary's founders think the message to come from the friendship between Bella and Tarra can be found in Steve Hartman's words: "They harbor no fears, no secrets, no prejudices. Just two living creatures who somehow managed to look past their immense differences. Take a good look America. Take a good look world. If they can do it—what's our excuse?"

About the Author

Kelly Kazek is managing editor of the *News Courier* in Athens, Alabama. In over two decades as a journalist, she has won more than 125 national and state press awards. She is the author of *Fairly Odd Mother: Musings of a Slightly Off Southern Mom*, a collection of her syndicated humor columns; *Forgotten Tales of Alabama*; *A History of Alabama's Deadliest Tornadoes: Disaster in Dixie*; and *Images of America: Athens and Limestone County*. She lives in Madison, Alabama, with her daughter Shannon, their beagle Lucy and cats Mad Max, Luvey and Charley.

visit us at
www.historypress.net